2,4,6,7

Real Lives

ART TEACHERS
AND THE CULTURES OF SCHOOL

Tom Anderson

D1264372

HEINEMANN
Portsmouth, NH

Heinemann

361 Hanover Street
Portsmouth, NH 03801–3912
www.heinemann.com

Offices and agents throughout the world

All text photographs were taken by the author, except for the photograph of Gayla Buyukas, which was taken by Sarah Hakimoglu.

Library of Congress Cataloging-in-Publication Data
Anderson, Tom, 1949–
 Real lives : art teachers and the cultures of school / Tom Anderson.
 p. cm.
 Includes bibliographical references.
 ISBN 0-325-00296-7 (paperback)
 1. Art teachers—United States—Biography. 2. Art—Study and teaching—United States. I. Title.

N89 .A53 2000
707'.1'273—dc21
 00-039552

Editor: Lois Bridges
Production: Vicki Kasabian
Cover design: Jenny Jensen Greenleaf
Cover photograph: Tom Anderson
Manufacturing: Louise Richardson

Printed in the United States of America on acid-free paper
T & C Digital 2010

Contents

ACKNOWLEDGMENTS *v*

PREFACE *1*

Introduction: Who Can Use This Book and How? *3*

1 Of Stories and Their Meanings *7*

2 John Ingebritson: Master of Aphorism *11*

3 Elizabeth Willett and Company:
Cooperative Vision Deep in the Heart of Texas *25*

4 Jean Price: Changing with the Times *45*

5 Maria Sarduy: A South Florida Perspective *61*

6 Gayla Buyukas: Teaching Art in an Urban
School-to-Work Program *77*

7 Donald Sheppard: Shepherd to the Community *92*

8 Study Guide *113*

APPENDIX: INTERVIEW GUIDE *118*

REFERENCES *121*

Acknowledgments

A number of people have helped and encouraged me on this project. Among them, I am most indebted to Sally McRorie, Chair of Art Education at Florida State University, who gave me the gifts of time; consistent, clear, and valuable feedback; and moral and financial support. I am also indebted to Mary Hippert of New Ulm, Minnesota; Professor Connie Landis of Montana State University, Billings; Ray Azcuy, Art Supervisor in the Miami-Dade Schools; Professor Emily Young of Portland State University; Professor John Siskar of Buffalo State College; and Beverly Fletcher, Art Supervisor for the Fort Worth Public Schools, for helping me contact teachers, some of whose stories are told here. Also, I want to acknowledge Dennis Lippert and Monte Dolack of Missoula, Montana; Jacques Bordeleau of Sun Valley, Idaho; and Nancy Walton of Great Falls, Montana, for leads, lodging, and feedback. Thanks to Dennis Lippert also for leading me to my editor at Heinemann, Lois Bridges. Her belief in this project made it a book, and her editorial wisdom made it a better book. Thanks also to production editor Vicki Kasabian and cover designer Jenny Jensen Greenleaf at Heinemann for their excellent work. I'd also like to thank Professor Pat Taylor of Piedmont College for his careful reading and valuable feedback during a critical phase of this project. Finally, I want to thank the art teachers who shared their stories with me and who are not otherwise represented in this volume due to publication length restrictions: Roy Carpenter of Flathead High School in Kalispell, Montana; Suzanne Woyciechowicz of Rattlesnake Middle School in Missoula, Montana; Warren Straus of Ashland Senior High School in

Ashland, Oregon; Jim Wilson of South Davis Elementary School, in sub-urban Buffalo, New York; Steve Willis, formerly of Rickards High School in Tallahassee, Florida; and John Blackman of Wood River High School in Hailey, Idaho.

Preface

Having been in higher education for eighteen years, I've heard occasional rumblings from K–12 art teachers that I couldn't possibly know how it is out there today. I've even been told, "Kids are different now. You wouldn't last a day in the classroom." My ego firmly intact, I didn't really believe that, but they piqued my curiosity, and I decided to find out for myself. So I set out on an 8,500-mile journey across the United States to see whether what I have known about teaching art still holds true and, if not, what has changed and how. I wanted to know what it means to be an art teacher—right now, in the United States of America. The main question I asked art teachers was What do you really do, and what does it mean to you?

An Account of Six Art Teachers

The result is a day-in-the-life account of six art teachers. It consists primarily of the stories they tell about themselves and the meanings they attach to those stories. It's about what they do, what they believe, and what they value, as well as the frustrations and problems they bump up against in the course of teaching art. This is not a book about curriculum or learning theory, although the teachers discuss those topics. Rather it is grounded research exploring the narratives of good art teachers, who are the heart of good art programs everywhere.

My belief in writing this book is that by understanding the experiences of these teachers and the meanings they attach to their experiences we may gain some understanding of what it really means to teach art. To get as broad

a picture as possible, I've included the stories of teachers at the elementary, middle, and high school levels, in large and small communities and in different social conditions, from various parts of the United States. To get as deep a picture as possible I've mostly allowed each teacher to speak for him- or herself about the things that matter in each of their professional lives. Through these six varied yet frequently overlapping stories I've tried to portray how it feels and what it means to be an art teacher in the United States today.

My premise is that the stories we tell can be significant vehicles for meanings we hold true or significant. My challenge, then, to the reader, is to unwrap these stories as vehicles for meaning. All action, including teaching, is rudderless without a reason. As Neil Postman (1995) put it, we all need a god to serve. The careful reader of this text will uncover here reasons for teaching that run the range from personal to social and from practical to theoretical and spiritual.

The primary goal of this book is to give future art teachers a realistic picture of what life as an art teacher is like. Beyond that, its goal is to provide both preservice students and teachers, as well as teachers continuing their education, with some grist for the mill—to inspire reflection and discussion about what they think counts in the world of teaching art.

Introduction

Who Can Use This Book and How?

This is an examination of what it means to teach art: a sampling of wisdom from the field offered by those who do the job day in and day out. Most broadly, I hope these stories are interesting in their own right and will appeal to the general reader for their fundamental human interest, but they are specifically intended to provide insights and lessons to those considering teaching art, to students returning from the field for graduate work, and to inservice teachers who want information or even inspiration for the art of teaching.

It is my belief that this book will give undergraduate art education majors teaching insights and will inform their decision about whether or not to teach art. For graduate students, it can be a valuable source of material for discussion and analysis of important human issues—social and psychological—in the field of art education. This book can be useful in art education foundations and methods courses, as well as in graduate seminars, to explore these teachers' drives, rewards, and frustrations. Beyond this, it also can be used to extract issues and themes in the field, such as common instructional strategies, discipline techniques, routines, art content, the logistics of materials and tools, and so on, in a realistic, nonformulaic way.

This book can be used in conjunction with the in-school observations and participation required in most art education methods classes, to compare students' own observations with the narratives of the teachers in the book. Most programs now place preservice students in schools for observation, but in the case of evening classes, summer classes, or other circum-

stances where students can't get into the schools, this book might even serve as a substitute.

Using the study guide at the end of the book, art education students can examine the narratives thematically to get a sense of what it is to be an art teacher: the issues, the rewards, the frustrations, a sense of the workaday world of teaching art. I expect that this will encourage some preservice students to continue and scare away others. Like observation and participation itself, that's how it should be. It's better that those who are not suited to teaching find out during preservice rather than spend years as bad art teachers. Also, inservice art teachers may want to use the study guide as a starting point to address or readdress issues that may not recently have surfaced for them. And certainly, art education faculty could use it to frame discussion in their classes—or even among themselves.

In graduate level/seminar courses, this book can be used in an open-ended way to stimulate analysis, interpretation, and evaluation of art education theory and practice. For example, returning master's- or doctoral-level teachers can test their own experiences against those of the teachers whose narratives are represented: an activity that has produced lively discussion in my own classes. It might also be very helpful, in conjunction with other readings, in exploring some of the gaps between the ideal (theory) and the real (what actually happens in practice) and in giving both those returning to the classroom and those planning to be teacher educators a practical and applicable foundation.

On a broader plane, I think that this book can be useful at the graduate level in examining the social foundations of art education. The content of this book will provide critical readers with a full and unending source—a spring rather than a reservoir—for continued exploration of issues and concepts in art education. Advanced students also will recognize that there is rich ground to be mined from the narratives in the multiple themes and issues to be constructed and explored from their content. Finally, those interested in field and interview research may want to examine whether aspects of this book would prove useful to them in constructing their own research.

Four Levels of Approach

At the most basic and literal level, these are the stories of six art teachers who work with urban, rural, black, white, Hispanic, privileged, and challenged populations from Oregon to Florida and from Texas to Minnesota. The simplest approach to understanding them is to read them and take their stories at face value.

The second-level approach is to take the stories as models for how art teachers operate in the cultures of school. At this level, readers may take lessons and insights through focusing on the nature and quality of the content being taught, the ways that content is taught, the logistical, motivational, and disciplinary strategies employed, and so on. They also may focus on the human (social and personal) context of teaching art in the United States as represented by these teachers. What factors influence one to teach art, how does it feel, and what is it like as a life choice? At this level, too, students may use the text to examine what connects as well as distinguishes rural and urban teachers, black and white teachers, men and women, jewelers and painters, Easterners and Westerners and Northerners and Southerners, and so on.

And while each teacher's individuality in his or her own authentic context provides the human heart of the story, the stories contained here are useful at a third level for beginning to construct (or deconstruct) patterns of meaning in a philosophical context. They may be used as the springboard to address the reasons for and value of art in education and the nature of teaching and learning art in American society. In my own search for patterns, themes, meanings, and significance in these stories, I've come to recognize that this book uses the framework of art education to ask questions that are central to all of us in our work and in our lives: Why and how do we do what we do? What is it for? What is it worth? What does a life mean spent in this way? Ultimately, of what value is what I do in the world?

However, I have resisted the temptation to provide my own answers to these questions, except at a very rudimentary level as an introduction to the study guide, because my answers won't help students find their own way. As art teacher Maria Sarduy, from Hialeah, Florida, puts it, "Ultimately you have to decide for yourself how you're going to do things."

In the study guide I have provided some of the questions that naturally arise when analyzing the stories at levels two and three, to help the reader uncover his or her own answers. These questions are centered on issues and themes that really count in the lives of these six teachers and that emerged in their stories. Whether the reader agrees or disagrees with a teacher's position seems less important to me than that it be considered. The questions are designed to promote this individual examination, possibly as a written assignment, and to frame interactive discussion of issues and ideas in the art education classroom. Through this process, readers may be encouraged to construct their own ideas about what it means to teach art.

Finally, at the fourth level, I think analysis and discussion of the research strategies used in this text could provide a stimulus for continuing primary field research methods in art education.

Ethnographic — branch of anthropology dealing with scientific description of individual cultures

1
Of Stories and Their Meanings

What follows are the stories of six art teachers, who teach various grade levels, who have various approaches to teaching, who exist in various social and geographic situations in the United States. The stories are mine, but I have tried to be as true to the participants' meanings as I can manage given my own intelligence, sensitivity, perception, and storytelling ability. I used interviews as the primary research tool believing with Seidman (1998) that one of the best and most direct ways of understanding how people see the world is to ask them.

My secondary tool, used primarily as a check against the interviews, was field observations. Beyond the internal coherence of a story the best check I know for truth is to see whether someone "walks their talk." So I followed each teacher around for two or three days to get a sense of whether what they told me had the ring of truth. I do not call these observations ethnographic research because two days is scarcely time for the emergence of deep meanings in an anthropological sense. Still, representing people through careful observation in their environments for even brief episodes has a long ethnographic precedent (R. Anderson 2000), and I feel that much that is authentic did arise from the observations due, in part, to my educated familiarity with the issues and environments of art education (Eisner 1991) and due to the fact that they were the supporting, rather than primary, research mechanism.

In my observations, I tried to be as unobtrusive as possible, asking the teacher to tell students, if they asked, that I was observing the teacher and not the students. I asked the teacher to ignore me during the course of the day, and this helped students not to be distracted by my presence. In most cases, in fact, I think I was little more interesting than the wallpaper: just a middle-aged man sitting in one corner of the room and then another, doodling in a notebook.

In this doodled notebook I kept a record of my observations, impressions, and intuitions (Emerson, Fretz, and Shaw 1995). In addition, I noted what seemed to be emerging patterns and themes rising from the evidence and frequently tied them to art education theory and practice (Eisner 1991).

Such observation and analysis frequently generated or guided some of the questions I would ask during the interviews (Seidman 1998).

I used a handheld tape recorder with a built-in microphone on which I recorded an extended interview with each teacher directed by the open-ended interview guide (see the appendix). The tape recorder was also used fairly often to get some pithy statements from the teachers during breaks in the action. It was never used during the instructional periods, and only used very sparingly when students were present, as I feared that it would be too intrusive.

I also took pictures of the teachers and their teaching environments. Many of these are represented in this book, but others were consulted only to refresh my memory in writing individual narratives. As with the tape recorder, I tried to avoid taking pictures while instruction was going on so as not to be any more intrusive than necessary. The pictures I did take during instructional time were almost always taken toward the end of my visit, when students were used to my presence and I had a pretty good idea that the classroom situation would not be altered by the picture-taking process.

The interviews were loosely based on a structure suggested by Seidman (1998), which has three parts. First is context-setting, general, background information. Second is a description of the events/phenomena that are of interest. And finally, the person being interviewed is asked to interpret the events he or she has described. This third part is in a broad sense the "so what?" section.

In the accounts that follow, the two- or three-day observation period is fictionalized as a single day-in-the-life, but any event described did, in fact, occur at some point during the course of time I spent with a given teacher.

Theoretical Foundations

This is a narrative account, not a scientific study. As Postman (1995) put it, "Our genius lies in our capacity to make meaning through the creation of narratives that give point to our labors, exalt our history, elucidate the present, and give direction to the future" (7). By their very nature narratives don't have to be provable in the scientific sense. They only have to ring true. The test of that is whether they're internally coherent and externally useful in helping us understand something meaningful about ourselves and our world.

Common sense tells there's an objective world beyond us, but the act of conscious perception and interpretation that constitutes our interaction with that world as well as the application of our prior experiences (Dewey 1934) inevitably casts it as subjective (Emerson, Fretz, and Shaw 1995; MacDougall

1995; Marcus and Fischer 1986). Just as certainly as there is something real to experience, we also bring our subjective attitudes, predilections, and prior experience to our perceptions. Meaning, then, lies not in the objective world nor in the subjective self but in the transaction between them (Eisner 1991).

So I freely admit that I have been the instrument of selection in these narratives, determining what was put in and what was left out. But I will argue that I was sincerely attempting to reconstruct and was consciously attuned to the teachers' own meanings to the very best of my ability. As Geertz (1973) points out, there's a big difference between a twitch and a wink, and we can only understand the blinking eye as one or another through grasping the twitcher/winker's subjective/expressive intent in a socially interactive context. In constructing these stories, it was my role to distinguish the difference between a twitch and a wink. It's my own sensibility, my intuition, my informed sense of what's right and true in the larger context of art education that was the primary interpretive instrument here. For that I relied heavily on my own informed sense of what's what in art education.

In the interpretation of meaning in a study such as this, one must consciously incorporate not only the facts of the matter but the emotions attached to those facts. The arts and humanities and certain social sciences have evolved to sniff out such meanings, and art critics, anthropologists, and novelists know full well the fictional nature of interpretation (T. Anderson 1995; Emerson, Fretz, and Shaw 1995; Eisner 1991; Dewey 1934). However, fictional in this case definitely does not mean false. The best of humanistic fictions—good novels, critiques, anthropological reports, and the like—in fact always tell us something truly meaningful about the nature of existence. They are stories that make sense. To do this, the storyteller selects themes appropriate to the situations presented. S/he sincerely attempts to represent through the construction of a persuasive narrative some aspect of a felt, "real" experience, believing that there is transactive meaning and human significance embedded in it. S/he represents not scientific truth but a sort of subjective reality—a narrative—which can be tested for veracity not through scientific methods, but in life (Dewey 1934). As Neils Bohr (Postman 1995) has stated, "The opposite of a correct statement is an incorrect statement, but the opposite of a profound truth is another profound truth" (11).

Voice and Presentation

Suzi Gablik (1997), in her introduction to *Conversations Before the End of Time*, argues for an interviewing approach with no specific story line or agenda in mind. Like her, I've engaged in a dialogue with my participants in

which I tried to "have and maintain my own point of view while at the same time trying to understand and include another's" (20). Gablik discusses how listening respectfully with no preconceived agenda opens us up to each other, and that this sharing of consciousness is a bedrock of community, allowing the truth to emerge not from any single point of view, but from many. In this work I have tried not to judge what I was being told so much as to simply receive it, acknowledge it, and create a space for it to be presented.

But for me to attempt to neuter my own voice in the presentation of these stories would not only be false and misleading but would weaken my authenticity and authority as the author of this work. I want to be forthright in reiterating that the point of view in this book, obviously, is mine. I have consciously used my own sensibilities and my own voice to present and analyze the accounts that ensue. I freely admit to being the instrument of perception, interpretation, and evaluation in what follows. And although each teacher has had the opportunity to give me feedback on his/her individual story—in ethnographic jargon, this is called a "member check"—I am the final storyteller. I've tried to represent the teachers' voices by making their stories as true to life as I can manage. Whether there's anything approaching profound truth here remains to be seen, but to the extent that there is any real substance, there could certainly be other equally significant points of view. What I've attempted in this narrative is not only to convey the story of six art teachers, but to also give a sense about what it means to be an art teacher at the turn of the millennium in the United States of America. Someone else observing the same teachers, for different reasons, with a different sensibility, would have written a different narrative, but this is my story, and I'll stand by it.

2

John Ingebritson

Master of Aphorism

The First Day of School

"How was your summer?" asked Mr. Ingbebritson.

One of the boys who had just come in was getting the chess set out of Mr. Ingebritson's cabinet. "Too short," he said.

Mr. I, as the kids call him, thinks that summer is actually too long, that kids forget things over the summer. He thinks shorter summers would elim- *like* inate unnecessary review and repetition each fall. *modified*

"I think it would be nice," he told me, "if we had our school year spread *tradition* out a little more so there are more breaks. I think it would be good for the students and I think it would be good for the instructors, so they don't become too exhausted. Students aren't needed on the farm as much any- more, so we could shorten summer, and we could extend the school calen- dar a few days. I think we could benefit from that."

Of course that's not what he said to the eighth-grade boys in his room at 7:30 on this first day back after summer vacation. Instead he sympathized, telling them he was glad to have them back, that he was looking forward to a good year.

"Are you going to be in my art class?" he asked.

"No, not this year," said one.

"Well, I'll look forward to seeing you in the mornings, then," said Mr. I.

It turns out that Ingebritson is the resident sponsor for the intramural chess club. It's "to make good use of time in the morning," he said. "And we have a tournament. But it's just to encourage novice players to learn chess. It's completely intramural—in the school. It's a volunteer activity. It's not something I'm paid for. It's just something I like to do because I like chess and I like the kids."

We were standing out in the hall in front of his math room before first period as he told me this. His art room is just across the hall. Fresh-scrubbed kids were passing back and forth, getting into their freshly painted lockers, talking to each other with that first-day pubescent enthusiasm. Some of them—probably the seventh graders—were looking a little uncertain, like they were trying to figure out where to go and what to do.

"Are the faculty required to pull bus duty or that sort of thing?" I asked.

"No we're not. We are supposed to be in the halls before and after school and in between classes but we don't have anything like that. And extra duties are voluntary. You're not forced into them. They do encourage you to volunteer for things that you have an interest in, though."

New Ulm Junior High serves all of New Ulm and the surrounding area. Located in southern Minnesota, in the Minnesota River Valley, New Ulm is the commercial hub for farms and farming communities for miles in every direction. In spite of the small population, it's a geographically large school district with over 2,600 miles of bus routes, according to Ingebritson.

"School starts at 8:25," he told me, "but students begin to arrive about 45 minutes earlier because of the bussing. So we start with hall duty about 7:30, and that's when some of the kids come in and get out the chess boards."

The bell rang and we went into the art room.

"Since this is the first day, we'll have a little longer advising period," he told me.

Class Routines: A Structure for Order

He greeted his eighth-grade advisees as though he'd just seen them yesterday. As he took roll he directed students to their assigned seats. One hundred per-

cent of these students are white with northern European—mostly German—surnames. There are eleven girls, nine boys, and lots of blonde hair. The lone no-show on the class roster is named Rodriguez. Immediately after roll Mr. I began to reorient the students to school rules and regulations: where to sit during school assemblies, when picture day is and how it will work, when to go to lunch, and so on.

"Today's menu is chicken nuggets," he said. "I see a couple of new faces. Do you know how to get to the lunch room? Also, remember to keep your locker combination to yourself. That's very important."

Only after he was done with business did he introduce himself. In what turned out to be his standard introduction for the rest of the first day, he said, "I'm Mr. Ingebritson, but since that's a long name, you can call me Mr. I. I went to Augustana College in Sioux Falls, South Dakota, and majored in math and minored in art. I participated in wrestling and golf. Then I went into the Marine Corps and served as a platoon commander in Vietnam. I came back after that, finished my education at Mankato State University, and began teaching here in New Ulm. I've been here twenty-seven years so I guess I must like it, and I'm not planning on going anywhere.

"Does anyone have any questions about what they need to do? OK, here's something you can try until the bell rings. Draw this on your paper." He put a figure on the chalkboard:

IIIIII
IIIII
III
II
I

"It takes two players. Take as many [sticks] as you want but only from one row. Don't be the one who takes the last stick. Would anyone like to play me? I'm available if anyone would like to take me on."

A girl goes back to his desk to "take him on." I don't see who wins. The bell rings and his advisees are off to first period.

First period for Mr. I is math. He's passing out textbooks within ten seconds after the tardy bell rings, having the first person in each of the four rows pass them out even as the students come in.

"Can I sit here?" asks a boy.

"You'll have an assigned seat shortly," says Mr. I. "I have a brain teaser for you. Look up here at the board."

He puts up a basic math problem on the overhead projector at the front of the room and leaves it there as he assigns everyone a seat. His math aide is

helping pass out the last of the books. Mr. I has a math aide in each of his three math classes because the state of Minnesota provides funds for one for any student who is not meeting the basic state math competencies. Although Mr. I says there are three students who aren't meeting the competencies in this class, no one except the aide knows who they are, and she's not doing anything to give them away. I count twenty-five when all the kids are seated, again, all white, most ethnically German. New Ulm Junior High School is about as monocultural as it gets.

America's Most German Town?

Ingebritson, who's ethnically Norwegian, told me, "New Ulm is a German community. In fact, a magazine article stated that New Ulm is the most ethnically pure German city in the United States. There are a lot of people who have lived here since it was settled, and it has a tremendous history. It's always held this German identity. I think the community builds on permanency more than some others, steeped in its German orientation. Germans seem to be perfectionists I think, and so their building, for example, is quality oriented like the streetscapes. The streets are just a little bit wider than in other cities, and it makes the city look unique. It was striking to me the first time I drove through here when I graduated from college. I stopped and got a drink of water in an artesian well, looked back and said, 'John, there's a community you could live with.' Five years later we moved into town. And it's a nice town. Building-wise, they really do a nice job here. And other things too. Art, for example. You know they really support it. They have an arts council and it's a community that especially supports the performing arts and music."

New Ulm also has a German brewery with a German gift shop. There used to be two, and anyone in town can show you where the other one used to be. Then there's Octoberfest; Ingebritson designs the official mug every year. And on almost any main road leading into town there's a big sign with a German warrior from the middle ages in an iron helmet greeting you with "Willkommen." On the other side as you leave he says "Auf Wiedersehen." It turns out this guy is Herman, the fellow who unified Germany in the fourteenth century. On the river bluff, up the hill from downtown, is an immense "Herman" monument replete with an heroic statue of the fellow that seems a hundred feet high. I had to wonder at how such a small city could afford such a big monument. And the monument is right across the street from Martin Luther College—and everyone remembers where Martin Luther was from.

When Ingebritson found that I had some local ties he asked, "Are you a Lutheran?"

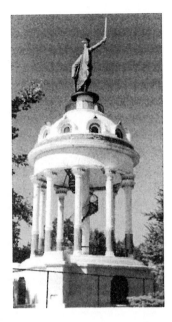

The "Herman" Monument, New Ulm, Minnesota

"Well," I said a little evasively, "My dad was."

He said, "I am too. We still have a really strong religious heritage here. There's a Catholic school system with about sixty kids per grade from K through 12. And there's a strong Lutheran system too, with about thirty kids per grade."

"Is that the Lutheran school with the sleek new building out there in the valley by Courtland?" I asked.

"That's it," he said. "And we accommodate the public school kids on Wednesday nights," he continued, "in the public schools, which is church night too, you know, for catechism, and church classes and choir and those kinds of things, so we don't give them any homework."

"So how many kids are in the public schools?" I asked.

"There are about 750 here at the junior high," he said. "That's down from a peak of about a thousand, when the town was growing a couple decades ago."

"How many people live here?"

"A little over 13,000, now," he said.

Making Connections to Life

Back in first period, about three minutes have passed and Mr. I has everyone in his or her assigned seat and is passing out textbook record forms. The stu-

dents are to note rips and tears and marks so they don't get charged for them at the end of the year.

"The number on my book is 1,093," says a boy in the second row.

"That's Mr. I's age," says another.

"No, it's his IQ," says a third.

Mr. I doesn't take the bait. He's on task and he wants them to be on task. He doesn't raise his voice, but continues with his own agenda: "Have your book covers on by Friday," he says. "Now let's get busy."

"Most things have a reason," he says. "The main reasons for math are keeping count of things, and keeping things in order. Oh, here's an interesting tidbit, by the way" (as if it had just occurred to him). "Our numbers are taken from the Arabs. The original Arabic numerals looked like this." He wrote them on the chalkboard.

"Can anybody figure how each figure relates to the number it represents?" he asks.

There's some class discussion before a student determines that each figure contains the number of angles that it represents.

"That's good," says Mr. I. "This is a good example of how there's a reason for everything. And history is really important in understanding some of those reasons. Now let's talk about something else that's really important in math. That's the ability to estimate. People who are good estimaters do well in life. You know, optimists are the other people who do well in life," he says as an aside. "Now here's your first estimation problem for the year. How many acres of land do think it takes to supply your needs for one year? Now think about not only the plants but the animals that eat the plants, and plants like cotton for clothing, and so on. Start figuring on these quarter sheets of paper. Use both sides. I like to conserve trees. Don't worry about a grade on this. We'll do some real problems later."

establishing rhythms

In the next period, across the hall in seventh-grade art, the first words from Mr. I's mouth are about seating, then he attends to materials trays for each student, then attendance. Then he sets about orienting students to his expectations. There are two lists on the chalkboard: one lists student responsibilities, the other, Mr. I's responsibilities. He talks about each point he's listed on the chalkboard. Under student responsibilities are attendance, participation, respect (given to and expected by every student), responsibility, and maturity. Under his own responsibilities, he lists curriculum (an interesting one that entails significant learning), protection of student rights, and help "in any way I can." Only when he has everyone and everything in their place does he introduce himself.

"Hi, My name, for those of you who don't know me, is Mr. Ingebritson,

but you can call me Mr. I. I went to Augustana College. . . ." He continues in the same manner as the two periods before, then says, "Now let's get busy."

"OK, who lives on a farm? Who can tell me what contour plowing is?" There are a couple of wrong guesses before one kid gets it right.

"That's right," says Ingebritson. "It follows the contour of the hills so soil won't get washed away. Well, think of the plowed furrows as lines. Just like that, contour lines follow the form of an object. They make two-dimensional objects appear three-dimensional. That's one of the things we're going to work on today. OK, divide your paper up into fourths, like this. We're going to work on some skills you'll need to complete our first still-life assignment. I want you to work along with me as I draw on the board."

He works out four simple forms that integrate the still-life skills he has in mind: contour lines, cross-hatching, value gradation, and one-point perspective. As he draws on the board and they follow him on paper, he delivers congruent information.

"By the way, students, artists know that where lines come together is very important. It's important not to be sloppy about that. Putting things together the right way is important. Not many people invent things. They just put different things together. Oh, and this one-point perspective is just an invention. A man named Leon Batiste invented it in 1475. It's not truth, just an invention.

[margin note: *perspectiv art hx foundation vocab.*]

"By the way, look at your pencil. It's just an average number two pencil. How long a line do you think it can make if you use all the lead in it?"

"A mile?" guesses a student.

"Longer," says Mr. I.

"Two miles?"

"Longer!"

"Five," say several.

"Longer!"

"Eight? Ten?" come guesses from around the room.

"Longer," says Mr. I. "It's thirty-five miles!"

"Wow!" say the kids, then it's back to perspective drawing, the students following Mr. I's lead.

"By the way," he says, putting down his chalk as though the next thought had just occurred to him. "Look at this poster by a famous Dutch artist named Rembrandt van Rijn who was really good at making shadows through cross-hatching. He also used contour lines to make things look rounded, and look here at the perspective. You know I didn't make these things up that we'll be using in our still-lifes. They come from history. This is an etching called *The Rat Catcher*."

[margin note: *make connections for art history-*]

soc. sci.
connection
history

With that, Mr. I starts to address the content of the image, talking about the garbage people threw in the streets in "the old days" and how it brought rats and how they brought disease. He tells the students how the people would hire rat catchers to get rid of the rats but that didn't address the real problem of lack of cleanliness.

"Maybe the real revolution was just learning to wash our hands," he says, then goes on to tie the rat-catching content of the poster into contemporary ecological concerns. Then he reminds the students of the story of the Pied Piper, and how he wasn't paid for leading the rats way. So he came back and led the children away.

real life
lesson

"What's the moral of this story, students? It's to pay what is due. That's an important thing. To pay what is due."

Then it's back to the directed drawing for a bit until he turns around again and says, "Do you know why a pencil has six sides?" and they're off on another guessing game, on another related tangent.

What's Being Taught?

Several other aspects of Ingebritson's teaching in these first encounters with his students are reinforced throughout the day. First, he institutes a strong sense of structure and discipline as the foundation for instruction. When I mentioned to him at the end of the day that I noted almost no misbehavior he told me it was because he assigns interesting and meaningful work and respects the students, and in turn expects them to respect him and each other and the discipline structures he has in place.

"I try to choose projects that are varied and interesting," he told me, "and also geared toward students' ability levels so they experience success. So they're proud of what they're doing because they've been able to accomplish something and feel good about it. If they're doing well and accomplishing something then they don't have to act out."

Second, he's theme oriented: He comments that the ecology, optimism, and problem-solving themes will be reinforced throughout the year.

Third, he's not afraid to diverge from the prescribed curriculum to engage in the teachable moment. Much of his most interesting material is off the prescribed topic. Ingebritson's teaching is like a bow on a package with loops that go out in all directions but keep coming back to the central knot he's made.

He told me later, "I think the most important thing I teach is lessons for life. And I get to kids in different ways. Some kids find and take things with them that other kids may not. Some lessons for life may be art related. For example, some of the skills they develop may carry over. They make take those

even further, not just in the art media realm but in their living. You know, some of the important things are—like good housekeeping, like cleanliness or care in accomplishing tasks—things that have to be addressed that maybe don't even have anything to do with art, but have a lot to do with living. In that way I hope there's a lot that happens in my classes. Life skills both in and out of art are what I care about. I want their art experiences to be enriching to their lives. I want the way they see and function in the world to be better because of art."

A look around his math and art rooms reinforces his focus on goals beyond either of his subject areas. Among the many aphorisms on posters and handmade calligraphic displays are a picture of a gorilla that says, "Thinking Allowed"; a head spurting out colors that says, "Free Knowledge: Bring Your Own Container"; three pictures of Einstein in the two rooms, one of which says, "Great spirits have always encountered violent opposition from mediocre minds"; and calligraphy that says, "Grow in wisdom, learn to love better."

Third and fourth periods are back in the math room, where the combination of high structure and discipline undergirding instruction are reinforced. Mr. I's version of discipline is soft-spoken and positive. Once when the students were becoming just slightly noisy he cued them with a simple, "Students," then a pause, before he said, "please finish filling out your book registration forms, now." He has good instincts in dealing with noise without confrontation or accusation. He smiles a lot during the day, encouraging students, rather than rebuking them.

"You catch more bees with honey than with vinegar," he told me.

Mr. I Tells All

Fourth period is split by lunch. Mr. Ingebritson and I took our brown-bag lunches down to the faculty lounge, where we sat at a round table. Three other male faculty members—a science teacher, an ag teacher, and a PE teacher—sat down, and within three minutes these four teachers who hadn't seen each other all summer were playing a round of bridge, just as though they'd seen each other yesterday. They ate as they played. One fellow asked if I was a hunter or a fisherman since I grew up in Montana.

"No I was a city kid, from Great Falls. I've never ridden a horse."

"No wonder they moved you off to Florida," he said.

With big guffaws all around, the game was over, class was starting in three minutes, and the bridge players were teachers again, putting trash in the barrel on their way back to class. I noted that Ingebritson, a youthful fifty-three, fit right in with his thirty-something colleagues as they moved out the door.

On the way back to fourth period, I asked him, "Why did you become an art teacher?"

"Coming back from Vietnam, I needed it. Art is a tremendous release and a tremendous way to focus and a tremendous way to heal. I found that it was good for me that way soon after I got into it. My mother had always said, 'Why don't you take up art?' and I just kinda laughed at her when I was younger but I never forgot that. Also, as I studied art I came to realize how important it is. I went to a workshop early on where the presenter told us that art is probably one of the most important things that people in history put value on, that endures. So that really made me feel good. And then he said you can measure the quality of education by the arts and the humanities. Are they offered and are they taken seriously? Truly that's where the pinnacle of your education is found.

"So I feel art is one of the most important subjects offered in school," he continued. "It has so many ramifications and plays to so many of your intellectual abilities. There probably isn't one that it doesn't touch on. But I also feel it's one of the most difficult subjects. It takes a tremendous amount of organization, and it takes a tremendous amount of management. And it takes time and skill to master it all."

"Are you satisfied with what you do?" I asked. "Have you ever thought about doing something else?"

"I'm very content at this point in my life, but I haven't always been. There've been times when I was interested in a change, and I think everybody goes through periods in their lives where they think it's greener on the other side. But I also believe it's important to find a row and hoe it, because if you stick with things there's good things that can come of that. So I've been fortunate in my job because I majored in math and they needed a math teacher, and I started teaching one hour of art, then a little more, and then for a while I was all math. Then they needed me more in art, so it's kind of worked out well for both the school district and myself that I could teach in both areas, and it sure makes it more interesting. The day doesn't get so repetitive. So it's stimulating."

"What's the best, most satisfying thing about your job?"

"I think you can tell when a lesson's gone well. In sports it would be like an adrenaline high, and I think you can almost feel that in a classroom situation. It's a real satisfying experience. It doesn't always happen but you can get to that point quite often so it's kind of addicting. It's nice. And kids feel good about themselves when things are going well and they'll come back and see you years later and bring up stuff and that's really rewarding. That makes it really worthwhile.

"And not just art," he continued. "In fact to a degree I would be doing

a disservice if I channeled too many people in that direction. I don't feel like I should challenge them to be artists. I should let their own free spirit move them in their own directions. So I feel that if I do something to help them along, that's what's important. In my first year I had a seventh-grade girl who in her drawing lessons showed that she was very good in art. I asked her what she wanted to do and she told me she wanted to become a nurse. I said, 'Well why don't you take it a little further and become a doctor?' 'Maybe,' she said. And you know, she did. Years later when she saw me, she came across the room to tell me that.

"Another student who was very good in drawing, and who would sit and talk with me, ended up going to MIT on a full ride. He eventually joined the Marine Corps, he's still with them. He's a lawyer. He was quite a guy. And I think in a way the little things we do as teachers carry through. We teach so much outside of our subject. And what's interesting is what and how we communicate. We think we're communicating when we're talking but a huge percent comes other ways, even through body language. The kids are watching us. We're giving them lessons about life."

"What's the most frustrating thing about your job, then?" I asked.

"I've had to learn to deal with certain stumbling blocks, things that take my energy. I think that's true of a lot of people as they grow older and mature. It may come in different forms. You may have a crisis on your life or whatever, but specifically, teaching art can be exhausting. You can put out so much energy that you can exhaust yourself. And I think the discipline of teaching art lends itself to that more than other disciplines because the job never ends. There's always something that can be done: for example, effectively showing artwork. I think it's important that students' work is displayed not just in the building but out of the building so they can be proud of their work and other people can view their work. That takes time and energy. It's an enjoyable job. It can be fun. But it takes a lot of effort.

"Another thing is managing and ordering supplies," he continued. "It's important not just to get good materials but to get the right amount, and to keep control of those materials so they're not destroyed, or wasted, or not effectively used. And then there's the environment. It takes a lot of work and training just to keep the environment in order.

"Another really frustrating thing is the bureaucracy. Unfortunately today, I think the government feels it can legislate good education. And it can't. So they're attempting to set up guidelines or standards, things that you should teach and that kids should supposedly know. The truth is that the lesson will be less effective if it doesn't come from the energy and desire of the instructor. The better teacher is the one who devotes himself or herself to the

discipline and subject and will teach from their heart and soul. You can't legislate that. So what I'm finding is, in writing and organizing curriculum and working with personalities, that you can lose a lot of energy and time on frustratingly meaningless activity in trying to fit a legislated standard."

"What do you think about the National Standards in Art?" I asked.

"When I first started teaching I went to meetings and researched those sorts of things because I wanted to learn as much as I could, but I ended up not feeling fulfilled, not thinking that's where or what I wanted to learn. Then I began to realize, 'I have this covered,' and it didn't bother me to stop attending those kinds of meetings. I can talk to anyone about my curriculum and show how it works and support it in relation to our standards and I feel my students have a good experience that will help them in the world. So I don't feel threatened by the standards and I don't get too involved with them."

He went on, "I do think it's important in teaching art to be current, though. I also think it's important to utilize videos. There are some very good sources where you can see artists demonstrating techniques, where you can bring artists into your classroom to add to your own demonstration. I think it's important for students to be exposed to different people. I think it's also important for students to have open-ended, hands-on experience where they're not locked into doing one thing or another. You tell them, 'You can practice this a certain way, but now take it further.' It's important not to stifle creativity.

"Teaching art is both a science and an art," he continued. "I mean, there are routines and some order but the art is knowing when and how, at what level, and with what motivations you can reach students, presenting things in such a way that it meets their needs. If you make it interesting enough you can virtually eliminate discipline problems."

"I noticed you didn't have any problems today at all," I said.

"Well, I don't usually have any problems. Earlier in my career I found that I'd have frustrated students when I'd give a problem that was too easy or too hard, or if I didn't present something in a way that allowed them to accomplish something. That's when you usually get your discipline problems. Or another is when they feel something is frivolous and not important. You need to support what you're doing with reasons, and they can see that somehow it's going to take them to a higher level then they'll go through it with you."

This philosophy was apparent in Ingebritson's teaching for the rest of the day. He was always seeking meanings and exhorting students to do so too. Frequently he'd ask students, "How'd you come up with that?" seeking an explication of the process rather than focusing on the answer. And frequently that would lead somewhere besides art or math, and that's often when the kids were really engaged.

process over
product/
object

"The answer is good," he told me, "but the process is primary."
"So what's the most important thing you teach?" I asked him.

"I've alluded to art history, art appreciation, media projects, and theory of art," he said, "but I feel the most important lessons for life are above and beyond what's found in the curriculum. Like that poster on the back wall says, Life is 10 percent what happens to us and 90 percent how we deal with it."

Profile: John Ingebritson

Current Position: Art and math teacher at New Ulm Junior High School, New Ulm, Minnesota.

Education: At Abbot Grade School, Albert Lea, Minnesota, Ingebritson had an art teacher who affected his life. "She was one of those art specialists that would come around every two weeks and I really looked forward to her and her lessons." He also attended Albert Lea Junior High and Albert Lea High School. He earned a B.A. in 1966, from Augustana College in Sioux Falls, South Dakota, where he majored in math and minored in art. He received a master of arts in art education in 1978, from Mankato State University. He says, "That degree was about fifty-four credit hours, but I ended up with over

a hundred. I had the G.I. Bill so I took everything—painting, etching, theory and history, and watercolor, and photography, and oh, it was wonderful!"

Practicing Artist: "I am, to a degree. We have a heritage festival, and for eight years now I've designed the [beer] stein, and will continue to do that. I've also done some classes in stained glass and wood carving offered through community education. I like to do art but I've found that after teaching art for twenty-seven years, I've devoted my energy to teaching, and I'm a teacher now, and really not an artist. It's different now than when I started. I don't feel the same need to get out of my classroom and do more art work the way I did then. My hope is that when I retire my energy level will come back and I'll go to art colonies and work with art groups more."

Teaching Experience: "This is my twenty-seventh year as a teacher here at New Ulm Junior High School and I love it."

Current Teaching Load: Three periods of math, two periods of art, a study hall, and a prep period within a traditional seven-period day.

Extra Professional Duties and Activities: Hall duty including bathroom checks before school and between classes, chess club, and "I've also been the girls' varsity golf coach for about twelve years. Over the years I've also helped on the football field. I sell hot dogs and stuff before the game, then during the game I run the line with a couple other teachers. We run the chains back and forth for the downs. It puts me right on the sidelines and I like that. I also help with judging in cross-country [racing]. They have a course set up and they need a person at one corner that's out of sight to make sure everyone makes the corners right. I like to do that."

Supplies and Expendables Budget: Between $4,000 and $5,000 for one-and-a-half teachers. "We are fortunate to have ample supplies and we get to order them ourselves so we get good quality. Especially younger people need good quality. It's very difficult for them to accomplish nice things with inferior-quality materials. But we've also proved that we can manage our supplies so we don't have a lot of waste. It's a good supplies budget and we don't have to have fund-raisers or that sort of thing so that's good."

Salary: "I'm not at the very top of the salary scale. I have a master's plus 30 [credits], and a master's plus 60 would be the very top, so I could get two more lanes, but I'm at the top of the scale otherwise. I make approximately $40,000 for a 183-day teaching contract year. And with coaching it's about $45,000."

3
Elizabeth Willett and Company

Cooperative Vision Deep in the Heart of Texas

"I understand you're selling pickles?" I asked.

"Yep," she said. "How do you know about that?"

"Beverly told me," I said.

"Oh, of course," she said. "That's right. The fountain is going to cost $900, so I'm selling pickles on Fridays to raise the money. I get them from Sam's Warehouse in those big jars and sell them for fifty cents apiece. We have about $500 so far."

"That's a lot of pickles," I said.

"Well, it's funny," she replied, "because children were giving me their lunch money for the garden and I had to do something about that."

The children were putting the money in an official, postal-style, street-side mailbox Elizabeth Willett has by the door in her art room at Oakhurst Elementary School. The mailbox is painted white with some brightly colored student handprints on it, and stands in a metal tub filled with cement.

Willett said, "I tell my children that because I don't have a homeroom and I don't see them on that sort of regular basis, if they ever want to talk to me, tell me anything, get me to do anything, or want to do anything for me, they need to [leave a note in the mailbox and] raise the flag, and I'll look in it. One day I was kidding around, and we'd been talking about how the garden needs money. So I told them they could leave me notes or presents or money. And I was laughing and they were laughing and everything was funny. But then I started getting these little envelopes and they were stapled together and they had change in them. And they were telling me, 'Ms. Willett, we love you and we're so glad you're teaching us, and here's some money for the garden.' I gave the money back, of course," said Willett, "and we had to work through that, but that's when I started selling the pickles."

ENVIRONMENT
Textures and Colors Make Up the Art Room

The first impression you get walking into Willett's third- through fifth-grade room is a little overwhelming. It's jam-packed with stuff, most of it colorful. On the far side from the door is a set of large bay windows with building supplies stacked up in front of them for what will be the Japanese garden just outside. Exposed heating pipes run along this wall about two feet from the ceiling, and hanging upside down from them are Japanese paper umbrellas. Hanging from each umbrella are five strings of origami cranes in fluorescent pinks, magentas, yellows, blues, and greens. A sink extends into the room on the end wall. On the counters, overflowing from the stuffed cabinets, are piles of markers and crayons, paper towels, scissors, and so on. On the cabinet doors are art and math charts, including Japanese numbers and their English equivalents.

By Willett's desk, an island table containing six computers juts out into the room. Willett says she used to keep student portfolios on computer disks but that it turned into a "nightmare" because every time there was an upgrade it made the disks obsolete and she'd have to reformat.

Pointing to the inside wall where a stack of portfolios takes up half the length on the floor, she said, "Now I keep all the 2-D work there, from third grade through fifth. Then they take home all three years' work when they leave here. But I have to send the 3-D work home," she said. "There's just nowhere to put it. I do photograph it, though, and I was thinking I could put it on a website. I'm working on that. I used to be very computer literate a few years ago but things change so rapidly I can't keep up. I pay for America On Line at school but I'm trying to get the school to pay for it. The holdup about being online is mainly getting parent permissions due to the possibility of seeing objectionable material on the Net. Anyway the [Fort Worth] Star Telegram has

Ms. Willett's handprint bulletin board

given me a free space, but the problem is trying to figure out how to construct my home page. They have helper seminars on Saturdays but I'm on the committee helping to prepare for the Texas Art Education Association meeting that will be here next month and I'm pretty busy with that on Saturdays now."

On the inside wall above the portfolios is a chalkboard with a large chart on it showing multiplication tables. Beside that, behind the mailbox and next to the door, is a marvelously colorful bulletin board covered with handprints in every imaginable color. They're in layers. The top layer is black handprints. The next layer down may be red or yellow; it's hard to tell. "There's a handprint there for every student I've had for years," said Willett.

why mult. tables? connecting to other subjects.

Although a wonderful display, Willett hasn't let the handprint ritual become precious. It still functions as a bulletin board, its primary purpose being to hang pictures, and Willett still pokes pins into its surface to do that. Finally, there were seven prints of David Bates' *Grassy Lake* hung in various places around the room. I would find out why shortly.

Art as an object w/ function

When I first walk in, Willett is sitting at a table in the middle of the room talking with her student teacher, Ginger. Willett is a tall woman in her thirties, with henna-red hair cut just below the ear. She is wearing a black linen jacket and skirt, a black cotton blouse, low slip-on black shoes, hoop earrings, a silver bracelet, and a long red- and black-beaded Indian necklace. Her manner is quiet and friendly. Ginger, from Texas Christian University, is just starting her second day after working six weeks in middle school. It feels

as though she's comfortable already, drawing on Willett's ambiance, which is—unlike the room—very calm, very collected, very low key.

Art Is Central at Oakhurst

Oakhurst Elementary School, in Fort Worth, Texas, is a vintage brown-brick building with red tiles on the pitched parts of the roof. It's in an older, lower-middle-class neighborhood close to the stockyard exit from I-35. The art room is in one of the oldest parts of the building. The initial structure, built in the 1920s, consisted of just four classrooms, the principal's office, and a bathroom. The part with the art room, built in the 1930s, was next.

Willett said, "This must have always been the art room. People in their seventies have come in visiting their grandchildren and told me they had art in this room."

Just as Willett's room is centrally located in the building, so her program is centrally located in the school's curriculum. It's the result of Willett's hard work, excellence as an art teacher, willingness to serve the school in all sorts of capacities, and the $162,000 in grant money she has recently secured, the bulk of which comes from an Annenberg/Getty grant. The Annenberg grant, and the Japanese peace garden project in particular, are integrative programs centering art in Oakhurst's curriculum. This centered status for art is unusual. Elementary art programs are usually among the last to be funded and the first to be cut.

As Fort Worth Public Schools Art Director Beverly Fletcher puts it, "At the elementary level we're always struggling to keep our programs because of site-based decision making, so many times we have to fight for our jobs and our programs."

Given this fact, Willett's expendables budget of about $6,000 for the year is astounding. She's quick to point out it's because of the grants. And she notes there have been times in the past when she's faced real struggles for resources and even survival, like two years ago when her budget was $350. But for now times are fat for Elizabeth Willett's art program. That explains the supplies stashed everywhere. Like a squirrel who knows summer isn't forever, she has tucked away goodies in all the cupboards and cabinets and has markers and scissors and paint and paper overflowing onto the countertops.

Good Question!

First period is Willett's planning period. At 9:15 the students come toward the art room. They're fourth graders. Ms. Willett meets them in the hall, lets

them know that she expects them to enter in an orderly manner, then lets them into the room. They're exceedingly orderly as they enter. One boy asks me if I'm David Bates as he goes by me.

"Nope," I say, glancing at the David Bates posters all around.

"Darn!" says the boy as he sits down.

Two children in this class are probably Anglo-American, three are Asian, STUDENTS and the rest are probably Hispanic, typical of the mix I was to see for the rest of the day. Standing by her mailbox in front of the bulletin board, Willett says to the class, "Today we're going to continue talking about this picture." She points to one of the *Grassy Lake* posters. "Who's the artist?" she asks.

About half the children raise their hands, she calls on one and he says, "David Bates!"

"Good," she says, "and the title?"

Another child volunteers, "*Grassy Lake.*"

"Good. What's it about?"

"Fishing," responds another child.

"Good, and remember we talked last time about things that were in the picture that gave us clues about what the men are doing. What are some of them? Yes, a tackle box, that's right. They're in a boat, good. Fishing poles, that's right. . . ."

Then she moves the discussion to formal/compositional issues. "What's the most important part of the picture?" she asks.

"The men," says a student.

"Why?" she asks.

"They are big, and in the center," says the student.

"What else?"

"The color," says a girl.

"What about the color?" she asks.

"It's bright on the men compared to the background."

"Good," she says. "Anything else?"

"There's an *X*," says another student.

"An *X*?" asks Willett.

"Yeah, where the paddles are," says the kid. "It like *X* marks the spot."

"Good," she says. "Now remember I want you to make the most important thing in your picture big like in the posters," she says, pointing to Bates' figures. "What else?"

"Put in stuff that shows what the story is," says a student.

"Right. I'm looking for lots of interesting details that help tell your story. And don't leave any white spaces. David Bates uses his whole picture space. Now, I'm going to pass your pictures back to you. Use these markers

when you're ready. I'll set the timer so you'll know when we have to stop." Willett turns on a computer program that was to play off and on for the rest of the day: a rotating set of paintings accompanied by classical music.

She begins to move around the room helping individual students, talking to them about their images. The student teacher, Ginger, also begins to circulate, emulating her.

"What could you do to make this look more like a boat?" Willett asks a boy. "What would David Bates do?" The boy points to a place on the poster where Bates executed a strong outline. Willett says, "Yeah, that'll work. You can look at David Bates and borrow his ideas. Artists do that." Then she turns to another child and says, "Why don't you get that box of overwriters [a kind of marker that changes colors when applied over other markers] and use them on the sky? That blue won't show up there against the sky. But wait, now, what time of day is your picture? That'll make a difference." To another student she says, "OK, let's have a look. What did we say had to be in the picture? Right. People. An activity. That's right. And no white showing. That's right. Oh, so you think maybe this isn't done, then? OK, keep on going. . . ."

"Look!" says another student excitedly, "It's raining ice in my picture!"

"You and your friend are in the pool there?" asks Willett.

"Yep."

"Well I hope it's an indoor pool," she says.

"Uh-huh," he says, obviously thinking how to rectify the conflict.

Then she takes another student, whose horizon isn't working, over to the window. They look together at how the sky goes all the way to the ground, and talk about how some objects like trees and buildings go through the horizon line up into the sky.

The timer rings. "Who needs more time?" she asks. Almost everybody does. "OK, let's keep going. Let's try to get them done so we can talk about them tomorrow." She begins to pin completed images up on the handprint bulletin board. "If you're finished you can get a piece of manila paper," she says.

Class mgmnt — *2° activity to keep kids busy*

Willett and Ginger consult briefly about the next group that will be coming in. Another five minutes go by and Willett says to the class, "You need to think about getting to a stopping place." The timer rings again. There are mutters and moans. The students want to keep working. But now time is really up. "OK," says Willett, "I'm looking for students who are following directions. Jean Paul, please get the markers. Marcus, pick up my pencils. Stephanie, the erasers. Luis, the pictures."

"Can I help please?" asks another student.

"I already have everything picked up," she says.

"Amud is ready. I like that." That's all she says, but they all drop into the "ready" mode, seated quietly at their tables. "Today we're going to line up with our Japanese number. Table *hachi* minus *ni* line up." They all look back at the cabinets to figure out who has been called and table six lines up. When the line has formed she says, "I need to see a straight line. If I see a straight line in here and everyone stays in their squares in the hall I'll let you get a drink." They file out quietly, in a straight line. Several wave at me as they leave.

Almost immediately—within twenty seconds—the next group files in, and the lesson on David Bates begins again. The same introduction, questioning, and reinforcement activities are performed. The same studio production is engaged. It feels like a well-oiled machine.

"Frankly, I can't remember the last time I had a discipline problem," *class mgmnt* Willett told me. "I was scared to death of discipline when I first started. Absolutely terrified. Then I discovered positive discipline. I try to use positive reinforcement as my discipline strategy and that's worked like a charm. It took me a while to really figure it out, but now I'll say just one positive thing and bam! There's no problem. That's why I can get so much done with these kids. I tell them at the beginning exactly what I expect and if they cooperate then we'll get do lots of stuff. And it's taken a long time but now I've had brothers and sisters and generations, so they know exactly what I expect when they walk in the door. But I think it also helps discipline when the students are motivated," she said.

"How do you motivate them?" I asked.

"Gosh, I don't know," she said. "It's one of those things that kind of happens. I do provide them with a safe environment to experiment. I want them to be excited about what they're able to do, and I think they can read it when I'm excited, and they're eager for me to be excited about what they're doing so the motivation just sort of builds. Very rarely do I have a kid who doesn't want to do something," she continued, "but I guess I don't know how that really happens."

By the time the third group rolls in, the lesson has been modeled twice and Ginger—Ms. Brown—takes over and does a good job. After the presentation both teachers begin to circulate.

"What activity are you showing here?" Ms. Brown asks a student.

"Basketball," he says.

"What other details will show that you're playing basketball?" she asks.

"I can't say it," he says.

"Say it in Spanish then," she says. He does. Elizabeth and Ginger look at each other. They don't know that word.

"The hoop!" say several kids in unison.

"Oh, right, good," says Ms. Willett. She doesn't speak much Spanish but it's OK. She isn't taken advantage of, as she well could be, because the kids like her. "This is the bilingual class," she tells me. "There's one at every grade level."

Willett holds up drawings in progress and tells the class what's good about them. "Like David Bates' this one has an *X* composition that shows you what's important." Then she holds up another and says, "Look at all the detail in this one."

Then there are conversations about the content.

"Is this your brother?" she asks one girl.

"Yeah."

"What's he doing now?"

"He's dropped out of school."

"Why?" asks Ms. Willett.

The girl explains.

"Bummer," says Willett.

Another girl shows her a drawing and says, "My sister and I dyed our hair blue and purple. Mine was blue. That's me there. But it lasted longer than we thought, so we had to go to Disney World with blue and purple hair. That's a rainbow sundown behind us so there are a lot of colors."

Never losing the balance between interested, empathetic listener and art teacher, Willett responds with a question about how it felt to have blue hair before she suggests that the hair, which is important, will get lost in the rainbow without some compositional changes.

Creativity, Concepts, and the Logistics of Teaching Art

At lunch, I asked Willett, "What's the relationship between creativity, concepts, and skills in your program?"

"I put creativity at the top of the list," she told me. "I want to see those creative ideas. That's what I'm going after. I want to see them find those ways to express what they're thinking, show what's going on with them. That's the main push. I think of my curriculum as being there to enhance their creativity by giving them some vehicles to express what they're feeling and thinking. As for skills and concepts, I think they need to know how to express themselves through basic ideas and principles that have worked before. That gives them the tools to express themselves."

Only third, fourth, and fifth graders get art at Oakhurst Elementary School. There are three special-area teachers in the school: Willett and two physical education teachers. There are about 360 students in the upper grades, so due to the nature of the rotation, Willett sees about 120 students

for two weeks, then another 120 the next two, and then the final 120 for another two, before starting over.

"It's a great schedule," she said. "I feel like I see them a lot more this way."

And of course she does. Third, fourth, and fifth graders at Oakhurst get twice as much art as kids in another school where the art teacher sees all grades. Certainly the lucky kids who do get to see Ms. Willett have a much more concentrated experience than their peers in other schools who see the art teacher on the standard once-a-week, forty-five-minute rotation. The drawback is that the kindergartners and first and second graders don't get to see Ms. Willett at all.

"But," said Willett, "I am going to have a chance to see kindergarten, first, and second grades. I haven't gotten to in the past but now I'll be able to see them—not very often, like maybe once a semester—but it's a start. And I used to only see fourth and fifth so we're making real progress."

Seeing the Big Picture

On the way back from lunch I asked Willett, "Do you have a lot of extra duties scheduled, liked committee work?"

"Well, I have regular duties like other teachers," she said. "It rotates. We have morning duty for a week. And lately we've been doing a lot of planning on our campus improvement plan for a site visit from the Texas Education Agency. So I'm on a lot of committees, but I'm thrilled to be on them, to have my input. You know some people think it's a terrible chore, but I think it's great to be included. And I want to attend all those meetings where we analyze the test scores and what we can do about them because I want to be seen as an academic teacher. I don't want to be a frill. I want to be an essential part—someone who's included in the planning, someone who has input in what's going on in the school—and I have to know what's going on to be effective in that. So lots of those extra jobs I take on myself."

I asked her to tell me more about her Annenberg challenge grant. She said, "Oh, I just do what I can. But really it was Beverly's idea."

Beverly Fletcher, Willett's art supervisor, also deftly deflects individual plaudits. "Oh, I just pull out some possibilities," said Fletcher, when asked about it. "It's the teachers that really make things happen. But you know," she continued, "the thing that happens in Fort Worth is that everyone pulls together. That's what makes it a special place."

If I'm typical, most outsiders don't know that. Those of us from elsewhere tend to think of Fort Worth as the second twin, the second city in the

metroplex. But don't tell the folks from Fort Worth that! Fort Worth is really proud of itself, and for good reason. Downtown, you'll see a lot of art—about an equal mix of modern abstract and cowboy sculptures, and they feel comfortable together. It's a town where the Gulf Coast greets the Great Plains, where southeast and southwest accents blend, where world-class rodeos and world-class art museums exist quite comfortably together. And the Kimbell, the Amon Carter, and the Modern Art museums are all within a few hundred yards of each other in the "cultural area," along with the Civic Center and the Will Rogers Tower and Exposition Grounds—the site of the largest annual stockyard show in the world. Beverly Fletcher took me around to the Kimbell, the Amon Carter, and the Sid Richardson museum collections, and in each place the curators, directors, and docents, without prompting, told me the same thing—the Fort Worth mantra—that what most characterizes the city is a down-to-earth sense of cooperation. In each museum someone proudly told me how they had avoided competing with each other through consciously choosing different foci.

This same sense of cooperation is evident between art museums and the Fort Worth Independent School District (ISD). ISD Art Director Beverly Fletcher is an ardent advocate of discipline-based art education (DBAE), and art museums are central to the discipline-based paradigm in that they provide necessary firsthand encounters with actual works of art. Also in the cooperative mix is the DBAE-centered, Getty-sponsored, North Texas Institute for Education in the Visual Arts (NTIEVA).

DBAE is grounded in the idea that knowledge is disciplinary in nature, that every mode of human accomplishment or endeavor, whether chemistry or history or visual art, has content and strategies unique to that discipline. Thus each discipline helps us to understand the world in a different way. Advocates of discipline-based art education argue that by focusing only on making art at school and ignoring the receptive/appreciative aspects of art, students are missing big chunks of information and important ways of understanding not only art, but life. They suggest that there are four equally important disciplines in art—art criticism, art history, aesthetics, and production. All four should be integrated in art instruction. The aim of education, according to this philosophy, is to imbue children with the skills and sensibilities of adult professionals in a given field of study. These ideas have made art museums central to discipline-based art education. In art museums students can be exposed to and can critically engage authentic adult paradigms of excellence from historical, critical, and aesthetic perspectives.

For the last fifteen years or so, the Getty Foundation has been the undisputed big dog on the art education scene, both theoretically and finan-

cially—so much so, in fact, that DBAE, with only minor adaptations, has become the official platform of the National Art Education Association. That was the political landscape the Annenberg Foundation found when it entered the arena of art education reform. Since DBAE has had no serious theoretical rivals, it probably made sense to this other big-money school reform foundation to climb on the Getty bandwagon. The Annenberg Foundation chose to put 4.3 million dollars toward art-centered schooling *current # of grants.* using the DBAE model. The Getty folks chipped in another 4.3 million, and the Annenberg/Getty initiative has made available thirty-six challenge grants to schools nationwide: six through NTIEVA and six through each of the other Getty regional institutes. According to Sally McRorie, codirector of the Florida Institute and a steering committee member for the national consortium, "These challenge grant schools will use art as the curricular focus for whole school reform with an emphasis on student achievement both in art and across the board."

Interdisciplinary Cooperation

Four of the thirty-six Annenberg/Getty grants were given to schools in Fort Worth. Elizabeth Willett has one of them. The grant's influence is obvious at Oakhurst, even early in the fall term of the first year. At about 3:50 P.M., Willett and the fourth-grade planning team are waiting for one last straggler to come in. School's been out since 3:25, and he's been called on the intercom. The team is trying to decide whether to start without him, but decide everyone's input is important, so they wait. They're meeting with a representative of NTIEVA and one from the Amon Carter Museum. As the teachers wait for the meeting to begin, the man on Willett's right tells her how nice she looks.

"You guys are really giving me away," she says.

"Yeah, well it's not like you usually come in your pajamas," another woman says, coming to her defense.

Finally, at 3:52 the last person arrives and the meeting, about the fourth-grade trip to the Amon Carter Museum, begins. The students will be expected to engage in a narrative writing activity resulting from the trip. As they did for every other art teacher in Dallas/Fort Worth, NTIEVA gave Willett a set of twenty-five art prints from five local art museums. The plan they develop in the meeting is to have the children go to the Amon Carter, look at the five paintings that the school has prints of, then come back and work from the "art links" (conceptual and aesthetic cueing devices) on the back of each art print to develop a piece of narrative writing. The commit-

‑tee frames the project so it will fit the Texas Assessment of Academic Achievement Skills (TAAAS) for the fourth grade under the category of "expressive narrative." To meet the requirements, each story must contain a general introduction, transitional words, an introduction and description of a character using lots of detail, the presentation of a problem, an explication of events, a resolution, and a conclusion. The committee discusses which artworks will be appropriate to use in accomplishing these tasks.

The school counselor is conducting the meeting, but it quickly becomes apparent that Willett is a leader here, in a quiet way. The group discusses bussing, lunches, arrival times, and logistics. As frequently as not, Willett has a solution the group will agree to, usually enthusiastically. She's a good abstract thinker and a good practical problem solver.

After the meeting, at 4:45, trying to think of a place to get a cup of coffee, Elizabeth says to me, "This is sort of the forgotten part of town. We'll have to drive to another quadrant."

Ethnically, Fort Worth is almost exactly one-third white, one-third black, and one-third Hispanic. The old Oakhurst neighborhood close to the school is predominantly Anglo-American, but the school's population is about 85 percent Mexican, with many of the children from transient families living in poverty or near-poverty. It's a neighborhood with Cost Plus grocery stores instead of Albertson's, Thrift Town and 99 Cent Stores, few banks, and no Barnes and Noble coffee shops. Billboards in the neighborhood are mostly in Spanish. So is the announcements sign out in front of the school. It reads, "Recojer reportes el jueves 2 de Octobre. 4:00–6:00." Since many children speak little English and only as a second language, at least one teacher at every grade level is required to speak Spanish.

These demographics give the school Title One status. Title One is a federally funded program that gives schools with "at-risk" kids added help in the form of Title One money. Two years ago, Willett was designated as the Title One teacher for Oakhurst by her new principal, so now her salary and budget come from Title One money. The catch is that Title One funds only so-called core learning: reading, writing, and arithmetic. Art isn't a core subject, so officially, Willett has been teaching math through art. Willett does not see this as a problem, but as an opportunity.

She pointed out the fact that she has a dual bachelor's degree in general elementary and art education, and said, "In Fort Worth, you need to have a certificate in elementary as well as art because you have to teach other subjects sometimes."

She's been at Oakhurst eleven years and says her job has changed many times since 1986, when, she said, "I had a homeroom and I taught kids read-

ing, writing, and arithmetic, and I taught art, I think, about three times a day. Then that changed so that I was the math teacher. I taught two or three sections of math and the rest of the day I taught art. Then one year I was basically self-contained," she continued. "I still taught two or three art classes but I taught all the other subjects as well.

"Recently, our new principal has changed our programs dramatically and that's how I came to be the Title One teacher. What I do now is teach math through art. That means, though, that I get to see every third-, fourth-, and fifth-grade student in my math-through-art classes. That's why I have multiplication tables on the blackboard and why I call them to line up by numbers or use a multiplication or subtraction problem. I also have them use charts to figure out math solutions in Japanese. So I'm trying to promote those thinking skills. Last year we were on the low performing list for the State Standards in writing, so my real push this year has shifted from math to writing and integrated lessons. I'm doing lots of curriculum enhancement throughout to focus on writing. So I tie in those two, like in the David Bates lesson.

"In fact," said Willett, "I love to teach art as an integrated subject. It's a really strong way to teach other subjects. I do not want to take away the integrity of the art though," she added. "I don't want art to be just a frill and I don't want it to just do other things. I want a strong art curriculum to support what they're doing in the classroom, but I don't want to give up the qualities that art has."

From what I've seen, she's struck the balance: in the David Bates lesson, in the Amon Carter field trip, and in the Japanese peace garden project.

The Japanese Connection

Willett says about the peace garden project, "It's my favorite. It's really exciting! We're building it at least partially with two grants I got last year, one for $2,000 from Sun and Star [a Japan-Texas cooperative organization] as seed money and one for $10,000 from the Rainwater Foundation, which is promoting outdoor classrooms and ecology in the schools. The peace garden really started when Sun and Star sent eight of us art teachers as ambassadors to our sister city, Nagaoka, Japan. We stayed in people's homes and visited art programs in the schools. It was great! We learned a lot and then we came back and put on a parade."

The parade was part of a ten-million-dollar Sun and Star Festival, centered in the Dallas/Fort Worth metroplex but also having exhibits in Corpus Christi, Houston, and elsewhere. ISD's Beverly Fletcher told me, "All the Fort

Worth Museums had exhibits from Japan, and our children were able to get funding to go on field trips and visit these exhibits—some of them went on as many as four trips. One major way the art department participated was to design and develop a children's parade. The project encompassed about six weeks, off and on, from February through September 1996, including four weeks of Japanese art and cultural education. We had a man come from Austin to teach us how to do origami, and a kite maker showed us how to make Japanese kites. The Japanese society members showed us how to use kimonos, taught us how to dance and use chopsticks, and held an all-day presentation on Japanese art and culture.

"But the major thing," she continued, "was the parade. Children from every school were involved. We had ten Japanese stories or festivals for them to choose from—like the Peach Boy story or the little Inch Boy or the festival they have when little girls turn six—and each school chose one of them. We had a float professionally designed for each one of the stories, and then the teachers and children added to them: stuff like six-foot paper carps that would blow in the wind, umbrellas, and paper cranes. And we got thousands of hospital gowns donated, and the children all designed *mons* [family crests] on the backs that reflected their particular story, and walked in the parade with these kimono costumes on.

"It was a walking parade," Fletcher continued, "in the Japanese manner. I think we had about 3,000 children in the parade, and I would say 15,000 to 20,000 worked on it. We bused more than 2,500 children, which was a phenomenal effort in itself. And the parents got involved, and the principals and even the janitors. And the cooperation between five organizations was phenomenal too. Think about it, the Japanese Society, the Fort Worth ISD, NTIE-VA, Downtown Fort Worth, Inc., and Imagination Celebration all working together. The thing that happens in Fort Worth is that everyone pulls together. But it was the teachers who made it happen. They stayed at school late and on weekends to create all of this and I give them all the credit.

"Anyway," said Fletcher, "This event was so big that you couldn't put a sheet of paper between the people lined up in downtown Fort Worth to watch. I'll bet [there were] 50,000. And it was a beautiful day. The breeze was blowing nicely, the sky was bright blue, we had radio and TV coverage. Our sister city, Nagaoka, sent 60 people to carry a *mikoshi* they had given us. A *mikoshi*," she told me, "is a statue that's a neighborhood god. This one is huge, made of wood and gold and bronze. It must weigh a thousand pounds. And they put these poles that cross under it and carry it that way. But the main thing was the children. Seeing the children get involved. And children from different schools carried their own *mikoshis*. One was a birthday cake.

One was a pair of shoes, if you can imagine a four-foot-tall pair of shoes. It was all so visually stimulating."

The story Willett and her students chose to portray was *Sadako and the Thousand Cranes*. Sadako was a victim of the bombing of Hiroshima and developed leukemia as a result. The story, in Japan, is that one can attain a wish by folding a thousand paper cranes. Of course Sadako wished to live and recover her health, so she began folding cranes. But she didn't make it to a thousand before she died.

According to Willett, "Her family and friends finished up and then buried her with the thousand cranes. Then they made a monument for her and every year they have a big celebration and school children send cranes and hang them on the monument and take pictures. It's really powerful to see the pictures." She continued, "So we folded a thousand paper cranes, and many of them are still hanging in my room. We hung them from umbrellas for the parade and we made giant paper cranes we carried on standards, too. And then we had a garland of cranes that we carried in the front and back. Not all my kids could do it [fold the cranes], but my fifth graders could and the fourth graders came close. We had to do a lot of basic origami first before we could do the cranes. I learned it pretty quickly because we had a wonderful guy here from Austin who taught us. And I practiced a whole lot. So we did the cranes and carried them in the parade.

"So it was natural," continued Willett, "for me to expand on the peace idea with the garden. My students need this. They had no clue about Japan, for example. We're a very closed society in a lot of ways. At first, we were just going to do a peace monument to Sadako, but it's grown and grown and grown. Beverly went to Dallas to see what they'd done and they'd done a garden. At the ceremony was an architect named Albert Kimotsu, who's a famous local architect who helped design the Fort Worth Japanese Garden, so she talked him into helping us. So it evolved from a monument into a garden right quick."

Willett took me out and showed me the space. It's about sixty feet square, right outside her art room window, and shaded by a single, big Live Oak tree. "Right now there's just piles of stuff here," she said. "But we're making good progress. The tree slices are from a mother and daughter who were upset about having to cut a tree down and wondered how it could be utilized, so we're going to use them as stepping stones in the garden. The pile of rocks over there is going to be a dry riverbed. That pile of wood is the bark that came off the tree, and we're going to use it as ground cover. And there's going to be a fountain right there," she said, pointing. "And my father's working with me on a bridge that's going to be right over there. He's building it in

Elizabeth Willett in her Japanese garden

Lubbock, and it weighs 500 pounds so we're trying to figure out how to get it from there to here, off the truck, and into the garden.

"It's really turning into a big community effort," she continued. "We've had lots of volunteers. We've had master gardeners who have been excited to help us, and the Japanese Society has adopted the project. Once we get the garden started, they want to come in and donate different parts. The parents group wants to give lanterns. I have Texas Christian University students call and ask how they can help. And—this is just wild—there's a guy who called me last week from the University of North Texas who wants to do his doctoral dissertation on it: something about the ecological impact of the garden on the students and faculty involved and possible curricular ties to science. This is getting big, and it's so much fun!" she said.

Going Beyond

When we stepped back into the room, Ginger had everything under control.

Willett said to me, "It's great to have a good student teacher like Ginger. I can get some of the stuff done that I need to do."

"What sorts of extra duties do you have?" I asked.

She rolled her eyes and laughed. "Besides the Annenberg grant and the peace garden? Oh, let's count them," she said. "I have tons and tons of commitments through art, but I guess the job that's keeping me busiest right now is preparing for the state [Texas Art Education Association (TAEA)] conference that'll be held here in Fort Worth next month. I'm the newsletter editor for TAEA. That's a huge job. The main thing right now is that I'm putting together the conference guide. The computer I use is at school so I do it after school usually. I'd say right now I'm putting in twenty hours a week on that. It's not always that much, though. You know there are off times. . . . Oh," she suddenly remembered, "and I'm the organization's conference treasurer elect, too."

"Anything else?" I asked.

"Let's see," she said. "Well, my class didn't make this semester but I usually teach art for elementary education majors at TCU. That's a lot of work, but a lot of fun. And I'm involved with Imagination Celebration. That's the local Kennedy Center Initiative. I'm also involved with the Crayola Dream Makers program. I'm a district trainer and I do workshops for them. And I'm writing curriculum for them. That should be fun too," she said as we entered the art room, "since it's based on the parade and the peace garden."

Fifth, sixth, and seventh periods were a repeat of the morning: the orderly entry, the upbeat and intelligent presentation of the David Bates lesson, the math problems presented for lining up, and an orderly dismissal. Toward the end of sixth period, Beverly Fletcher came in with some curriculum materials for me.

"Elizabeth really helps these students to know artists," she said to me, and turning to the class she asked, "Can anyone tell me the name of an artist?"

"David Bates!" said several.

She looked a little confused just for an instant, like she was expecting to hear Monet or Picasso, like she was thinking, "Who in the world is David Bates?" then she smiled her infectiously expansive smile and said "Excellent! This is a wonderful class!" And she was out the door and gone.

During sixth period, Willett sat down for a minute at her desk and had a piece of candy and a drink of water. Then she was circulating again. It was the only time I saw her take a break all day.

"What do you think about teaching seven periods a day?" I asked her after school.

"Um, some days it gets a little long," she replied, "but I love it. I wouldn't choose not to see any of these kids. You know it's worth it if I get to see them all."

"Do you think elementary teachers work harder than secondary?" I asked.

She didn't take the bait. "Well, I wouldn't, I mean I don't . . . ," she stammered, then said, "Well I do work hard. I know that for sure."

Beverly Fletcher says that's one reason why Elizabeth Willett is an award-winning teacher. According to Fletcher, Willett won, among a much longer list of awards, TAEA's Outstanding Elementary Art Teacher award the previous year, the Oakhurst Teacher of the Year Award, the Adopt-a-School Outstanding Educator Award for the Fort Worth ISD, and the Outstanding Young Educator Award for the ISD in 1992. There was even an Elizabeth Willett Day proclaimed in Tarrant County in 1995, as a result of a huge exhibition Willett organized and hung in the county buildings downtown. "But," said Fletcher, "Elizabeth will not tell you about her awards."

Sure enough, when I asked she said "Oh, I was the outstanding educator for the district one year and there are some other plaques I don't really remember."

Another reason Willett is so successful, according to Fletcher, is that she has a vision. "I think Elizabeth's vision is that she performs a basic and sequential course of studies, and makes it fun in a way that ultimately meets the needs of each student," she said. "She's making a difference in her school. When I see her children I know they have an enriched background and vocabulary, which not only involves better manipulation of materials but allows them to do everything better and more confidently. I live in the area where her school is and know many of the children, and I know they love Elizabeth Willett. I mean, how often do children try to give their lunch money to the teacher?"

I wondered if that would be Elizabeth Willett's own reading of her vision, so I asked her, "What's the most important thing you teach?"

"Children," she said. "I think everyone's kind of crazy about test scores right now. It's a big push, but I also think teachers are beginning to see the value of their children having art on regular basis. I want my kids to leave here thinking positively about art, about what they can do, and by extension, positively about themselves. I want them not to hate new information when they have no reason to, not to be narrow. I want them to think, to be open, to not close down. I want them not to criticize each other, [but] to look at the differences they produce and say that's OK. That's what I want."

A final piece of the puzzle and a big part of Willett's success, if you were to ask her principal or her art supervisor or her peer teachers, would be her cooperative spirit. She seems to have the knowledge, lost to many of us, that

one true power of human beings is the ability to work together in groups. Willett really embodies the Fort Worth mantra that everyone pulls together.

I had just a couple more questions to ask her. "So," I said, "you seem really pretty satisfied with what you do. Are you?"

"I'm very satisfied," Willett said. "I love what I'm doing. And the only reason I'm still doing it is that it's so satisfying. The children are so satisfying. That's the part I couldn't give up. The kids. And that's the main part of what I do so it all makes sense for now. But," she added, "I'm always looking to the future."

"What would you change," I asked her, "to make your job easier, to make you a more effective art teacher?"

"Well, there's always room for improvement," she said. "I adapt my curriculum regularly. But I guess if you could add more hours to the day, that would help."

Profile: Elizabeth Willett

Current Position: Art teacher (Title One teacher, teaching math and writing skills through art), Oakhurst Elementary School, Fort Worth, Texas.

Education: K–12 in Lubbock, Texas; bachelor's degree in elementary education and art education (dual degree in three years) from Texas Christian University, Fort Worth, Texas, 1985; master of science in education (administrative supervision in the visual arts) from Bank Street College of Education and the Parsons School of Design, New York City, 1989.

Practicing Artist: "Uh, yeah, I guess. Probably not in lots of people's view, but I do a lot of computer-oriented things, computer-assisted graphic design, so I do some. I did a lot of art in my master's program, but now I think of teaching as my art."

Teaching Experience: She's in her eleventh year at Oakhurst Elementary School. Before that she taught a half year at McMillian Primary School in Dallas.

Current Teaching Load: Seven periods a day of third-, fourth-, and fifth-grade art.

Extra Professional Duties and Activities: Annenberg Grant Principle Investigator, fourth-grade team member, Oakhurst Elementary School; Art Corps teacher, curriculum and materials developer for Imagination Celebration, a Kennedy Center–funded arts organization; curriculum writer

and district trainer, Binney and Smith/Crayola Dream Makers Programs; newsletter editor and treasurer-elect, Texas Art Education Association; adjunct instructor for art in the elementary education courses, Texas Christian University; conference treasurer and elementary division chair for the Texas Art Education Association.

Supplies and Expendables Budget: Last year it was about $6,000, but that was because of the grants she received. The year before it was about $350, which was also unusual on the low end. Normally she gets about $1,000 a year.

Salary: "About $34,000. In relation to other districts in the state we do pretty well. Nationally we don't. We do have a strong teacher group that pushes for salary. It's important that we're paid as professionals. There used to be a career ladder that was a sort of merit pay and I was able to get to level two, which has meant an extra $3,000 a year. Although they're still paying teachers who made gains, the program has been discontinued and now we're paid in steps—every year is another step—plus a cost-of-living increase."

4

Jean Price

Changing with the Times

When Jean Price ventures to the edge of town, what she sees are wheat fields, sage brush, and distant blue mountains. The tree-lined streets of Great Falls are an artificial oasis on the high, dry Montana prairie. With a population of about 55,000, Great Falls is a small city by most standards, but in Montana it's an urban center. In fact, not too many years ago when the population was 65,000 or more, it claimed to be the biggest city in five states. But there's been no growth in Great Falls for years, so except for a stretch that goes down the river, there's no urban sprawl. The town just stops and there you are, out on the prairie.

The city straddles the Great Falls of the Missouri, famous for the trouble they caused Lewis and Clark, who ended up portaging them. Since then the falls have been tamed. Now huge turbine-turning dams give Great Falls the nickname of the Electric City. Malmstrom Air Force Base sits on the edge of town, providing a bit of cultural diversity; the few black people you'll see

in the mall are almost certainly connected with the base. Malmstrom also centers a huge complex of about two hundred Intercontinental Ballistic Missiles—relics of the Cold War—discreetly and inconspicuously placed in sagebrush-covered silos for hundreds of square miles in every direction.

The Western Art Heritage

Great Falls is a pretty conservative place: a meat-and-potatoes kind of town. It has a no-nonsense feel about it, like the rural Midwest, but with a few cowboys and a museum built to honor cowboy artist Charles M. Russell. Great Falls was Russell's home during his mature, productive years. His log cabin studio has been preserved on the museum grounds, and the staff there claims to have the largest Charlie Russell collection in existence.

According to Great Falls High School art teacher, Jean Price, there is, in fact, strong support for western [cowboy] art in Great Falls: "the C. M. Russell regime," as she puts it. "But," she says, "if you don't fall into that category, support for art deteriorates real fast. We do have Paris Gibson Square Museum of Art, which is a contemporary facility. But if you drive by the parking lot at the Russell Museum and then by Paris Gibson Square, the first is full—even buses are sitting out front—while there are maybe five cars at the Square."

"Is that as it should be, in your mind, or not?" I asked.

"Well I wouldn't take anything away from old Charlie Russell at all," she said. "I'd just like to see a more even distribution of support and appreciation in art. He's just one artist, one type of art, but of course his name does bring a lot of revenue into the community. They have the Russell auction in the spring, which is a big, big thing. Thousands and thousands of people come from all over the country. They take over the Heritage Inn, the first and part of the second floor; they take the beds out of the rooms and each one of those rooms becomes a little gallery. That was the way it started. Now three or four more hotels downtown are being used because everybody couldn't get into the auction at the Heritage Inn. But it's all western, wildlife, regional kind of stuff."

"Where does the money go?" I asked.

"Well, from the Russell auction itself, the money goes to support the Russell Museum. But in each of these little rooms—galleries really—they have to pay a fee to have that room and that probably goes to the Russell too, I suppose."

"So it's big business."

"Yeah, it's big business. And if we have a little auction at Paris Gibson Square to raise some money, it's embarrassing. Here half the artists are sit-

ting right there in the crowd and nobody's bidding on anything. Live auctions of contemporary artwork in this town make me so upset. Now the Yellowstone Museum, in Billings, runs a real respectable fund-raiser in the form of an auction. Big money gets spent there, but not here."

I asked her, "How does all of this translate to your teaching, if at all?"

"We do what we think is right," she said. "One of the things we do with funds we have raised—with our candy money—is every time the show changes at Paris Gibson Square, we rent a bus and we pile everybody on it and all day long we run it back and forth to Paris Gibson Square for tours of the exhibit. This happens about five times a school year. We're the only school that does that, and we're lucky because we're the only school that's realistically close enough to make it possible. We all, I'm afraid, shudder just a bit at the western art. But you have to be a little bit careful that you don't put it down too much because it isn't that it doesn't have a place in the world. It's just that it does have such a huge emphasis here."

I confirmed what she was telling me with my own testimony, telling her that when I was growing up in Great Falls I thought "western" art meant cowboy art, period. I told her how it was only when I was in college, when my art history professor made reference to Western art in relation to Leonardo and Rembrandt, that it dawned on me that Western art refers to the Anglo-European tradition, not just to Russell and Remington.

She laughed and said, "So many of the kids that come to me who are interested in art will come with the notion that western is what good art is. And that's the only kind of good art. We try to counteract that, and they've had elementary and middle school art classes, in which the western stuff hasn't been the only influence. But it's what's reinforced at home and by the community, partly because it's safe, of course. Western art is safe art."

"Well, what do you want your students to come out of your art program with as an alternative?" I asked her.

"An open mind," she said. "I want to broaden their horizons, especially the art workshop students, since many of them will never take another art class. Most of them will not be artists or even make art much on their own after they get out of my class, but I want them to be open to what other people are doing and to the diversity of possibilities. I want them to have the confidence that if they want to do something [in art] they can in fact do it, and enjoy it. Or even just use what they've learned to help them choose the things in their homes—that sort of thing. I want them to understand that art is not just what's hanging on the wall. It's a much more universal kind of thing that can add another level of wonderment to their lives. I want them to know that they can always keep changing and letting their

Teaching philosophy

aesthetic grow. They're not stuck with what their mom and dad thought was good art."

Advanced Placement Art Starts Early!

Jean Price works hard at opening kids' minds to art. She gets to work earlier than most of her colleagues to teach the two-hour Advanced Placement (AP) art class that starts at 7:00 A.M., an hour before its scheduled first period. "I have an overload," she tells me. "Six periods of instruction a day instead of five. I've been told this is my own choice and I'm trying to accept that. I come in at seven and teach my seniors in the Advanced Placement class. It's a two-hour class and that's the only way we can get it in. I've tried other ways of going about it but this is the most comfortable solution for me."

"Why do the kids come at seven?" I asked. "What's in it for them?"

"They love it. The art, I mean," she said. "They're motivated because they love art. And they recognize the great benefit of being able to stay focused on what they're doing for two periods in a row instead of breaking off, especially with the time involved in cleanup and all. Besides, they have their choice of parking places at this hour that those later folks have to struggle for. I tried doing it sixth and seventh period, but since it's all seniors, most of them were out of the building by the end of fifth period and that didn't work out, so I tried it at 7:00 A.M. once and it's worked out."

We were talking in Price's second-floor office, which abuts her classroom in the newly reconstructed art department. The three art teachers had a major role in redesigning what used to be the woodshop above the stage into the present facility. As we talked, the students started coming in and began to get their projects and tools out.

Ten students are there by 7:00 A.M. One student, an Ani DiFranco fan, puts a CD in the changer, and assures Ms. Price, "There's only one place where [DiFranco] says 'hell' and it's pretty mellow music. And don't worry, Ms. P., we'll still have a mix of your music and ours on the changer." Another kid slips a CD called *Man and Astro Man* on the changer without really discussing it. As first period goes along it becomes apparent this second choice is not quite as mellow.

None of these students in first period looks obviously Native American but the assistant principal told me later that 200 of the 1,800 students at Great Falls High School are Native American—the second largest Native American enrollment in the state. But during the day there isn't much evidence of those kids. I don't see 10 percent of the kids who are obviously Native American at

any point during the day. I suspect that one quarter or one eighth Indian blood is enough to qualify for the purpose of school records.

There isn't much evidence of cultures other than middle-class white or much in the way of alternative sensibilities, either. For example, in this AP class, one boy has some moderately greased spiked hair, another a goatee. One girl has henna-colored hair and an eyebrow ring. Dress is pretty moderate all around.

The students are working at four large, sturdy tables. There's plenty of work room for these ten kids, but the room seems really full when twenty-four students arrive later on in the day. There's a cement floor, a large, triple-basin stainless steel sink, a drying rack, lots of good cabinet space, and a chalkboard. A spray booth and a paper cutter sit on the counter by the window. Above them run five "clotheslines" for hanging work-in-progress. A Mac computer and printer sit on a cart in the middle of the room. One large wall used for display has an ingenious stainless steel grid for clipping up works of art. An art history time line hangs above the grid. About ten posters are hung in various places around the room, ranging from an ad for the Savannah College of Art and Design to a slick poster that says "Design Is Everything."

Price began the AP class reminding students about how to proceed when they think they're finished with their drawings. "What do you do with a finished piece?" she asks. "How do you know when it's done? First you talk to the people at your table, get their feedback. After you've gone through peer review you bring it to me. If it's not an A or a B, it's not done. Remember to get off the smudgies. Does anyone need a demonstration of how to use a kneaded eraser? You've all used it, right? Then you need to spray [the piece] with fixative. Make sure the fan is on. Look."

Using work from a nearby student to show the finishing process, she demonstrates how to use the spray booth. "Then get a piece of butcher paper," she says, "and cover it. Let me show you where that is." She pauses, then adds, "I realize this is not the most creative part but it's really important that your work look as presentable as possible for photographing it for the AP."

After she's finished, a student asks, "Can I go to the bathroom?"

"If you're taking your break now," says Ms. Price.

"It's amazing that we're eighteen years old and still have to ask to go to the bathroom," says the girl. Later in the day, I remember what it's like—the tight controls on passage through Great Falls High School. As I go down the hall to the bathroom I pass at least three teachers strategically positioned at desks in the hall. As I pass them, they see a middle-aged man, maybe a distinguished visitor. But I feel reduced by their gaze once again to the level of

high school insecurity. "I'm only going to the bathroom and then I'll be right back," I feel like telling them.

Ms. Price isn't listening to the student's bathroom complaint. A diminutive woman, she's standing on a chair to get a little distance from a student's artwork that's lying on the table. She's squinting—unfocusing her eyes—to get a better sense of pattern. "Not now," she says to her bathroom complainer, "I'm unavailable. I'm unavailable." As the period moves along I see almost every kid standing on his or her chair at some point, engaged in a peer review. It seems to be part of the culture of this AP art class. "Walk around and look at what other people have done," she says to the group in

general. By the end of the two hours, Ms. Price herself has made it around to every student, stood on chairs in front of all their work, and engaged them meaningfully in dialogue about their images and strategies. She's not shy about sharing her opinion. She's very specific about what she thinks is good and not so good about the works in progress, addressing line quality, composition, value, forms, textures, and so on. Likewise, almost every student has talked to at least one other student about his or her work. There's a lot of art talk going on in here, at least in the form of critique.

Art Workshop: Comprehensive Art Education

Second period is Price's prep period. She has a student aide who is of minimal help and needs a lot of direction. Third, fourth, and fifth periods are foundations art classes called Art Workshop. Sixth period is crafts. According to Price, she and the other two art faculty members teach the eight sections of Art Workshop.

She told me, "Workshop is like Art One or Basic Art. Kids in the workshops can be any level, from ninth through twelfth grades. It fulfills the high school fine arts graduation credit for college-bound students, and it's also the prerequisite for any other art class we offer here, so we get a real diverse group of kids. Some are only in here because they figure they can't sing and the idea of being on a stage or in a drama production scares the socks off them. Some think it's the easiest class they could take. But some are really talented and they're in here because they really like art. Sometimes I think it would be nice if the talented kids could just test out of workshop, but on the other hand it's great to have those kids in here. It raises the level, the standard. It gives some of the other kids a look at what's possible."

One workshop student said to me, "This is the class you take to figure out what other art courses you're interested in."

Confirming this, Price said, "We do try to cover as many basic skills and concepts as possible in this class."

"So what are their advanced art options?" I asked.

"Well, we have two sections of commercial design, a section of fibers—crafts, really—and this year we have a new photography class. These are all one-period, yearlong courses. Then there's painting and drawing, which is a half-year, two-hour course. That alternates with sculptural design, a three-dimensional course taught for two hours a day in the second semester. We also offer a print-making class sometimes, but not this year. Oh, yeah, and AP, of course.

"Students can only use three credits [three classes] of art toward graduation, though," she continued. "That means that all the AP kids, I think

without exception, are not able to count that class toward graduation. I mean they get the credit, but it's extra. It doesn't help them fulfill their requirements."

"How many kids in a class?" I asked.

"About twenty-four," she said, "except AP, which is capped at fourteen. That's district policy for advanced placement classes."

"So there are somewhere around 350 kids in art in the school?"

"Yeah, that sounds about right," she said.

The workshop students are working on a narrative self-portrait. The emphasis is on symbolic imaging that tells a story. After the bell rings to begin the period, Ms. Price calls out, "OK, freeze!" They do. She calls their attention to the directions on the board—procedures they are to follow—then lets them go to work. After they've worked on their drawings about fifteen minutes she again calls them to order to give a presentation.

"OK," she says, "to get a good art product it's important that we tend to ideas in the process." She directs the students again to the chalkboard where she has written two questions about artist Elizabeth Layton: (1) What influenced her artwork? (2) How did she tell her story? "Remember, keep these questions in mind as we go through this. You'll have to answer these questions and I expect that something of these artists will come out in your own work. Yesterday, we had a look at Faith Ringgold. Today we're going to look at Elizabeth Layton."

Price begins to tell the students Elizabeth Layton's story, how she turned to art as a remedy for forty years of depression, how when she went back to college she started doing contour drawings, "just like you [students] are doing." The story is accompanied by overhead projections of Layton's work. Price continues by quizzing the students on the qualities they see in the work. She talks about the value of distortion for expressive effect and how character is projected in distortion. She shows multiple examples of artists' work that use distortion for effect and asks the students what effects they're seeing. Then it's tied back to contour drawing and the natural distortion that will occur in the beginning by looking at the object being drawn and not at the paper. She reassures the students that it's OK, in fact it's good, to exaggerate, to alter an image.

Then it's back to Layton's work. She talks about her art as narrative, as therapy, as composition that expresses something about the artist, then redirects and ties it to student production.

"See how she places the figure," says Price. "Think about the placement of your figure. Look how she's made her hand come out there. You could do something like that. Look how that arm leads into the image. It ties the figure

to the background. It might be fun to try something like that. And what's going on here?" she asks. And so it goes.

Her presentation swings between presenting information and asking orienting or critically leading questions. The kids don't know when they're going to be called on but know that it's real possibility at any time. Most of them seem not only awake, but quite interested. One image is about Layton's husband, Glen, who has his tackle all spread out in the kitchen and dreams of catching a big old catfish. Price shares her dream to be able to make more artwork, then, extending the narrative, describes how she, too, organizes her art materials and dreams of making art.

"But, she says, "then it's time to go to a meeting, or to work, or time to clean the house or something. It's easier to dream and to prepare than to actually take action on a dream." *[life lesson]*

By personalizing the message, Price has captured everyone's undivided attention. "So what do you dream about?" she asks. "What are your causes? What would you put on your list? And how could you show what you care about symbolically? What symbols will you use? How will you characterize yourself? What ways will you distort your image?" Price is very good at tying themes to forms, helping students understand that forms are a means of communication, that they represent something beyond themselves. *[Connect content to theme/subject]*

Keeping Up with Current Practices

After a brown-bag luncheon on the grass, outside the art room, periods four and five are the same as three, except that Price lets her student teacher, Ms. Stockmeyer, do most of the honors. She also lets her take the lead in period six, which is a crafts class. Price says it's great to have a good student teacher and she welcomes it almost as a team-teaching effort. It appears that Ms. Stockmeyer is up to the task. While Stockmeyer teaches, Ms. Price looks over the written responses from the periods before. Her integration of aesthetic, critical, and historical inquiry into her art program impressed me, so I asked her what role discipline-based art education (DBAE) plays in her curriculum.

"Well, in the latest curriculum revision we just finished working on, we were more concerned with more recent initiatives, particularly the National Standards, theme-based art education, benchmarks, and so on. You know, the latest lingo. We looked pretty hard at a curriculum from New York that was tied to the National Standards and took some cues from that. But the Getty came out with all that discipline-based information about the time we did our previous revision, maybe five or six years ago, and we made a major effort to include it. A lot of it is still in there. But realistically, if we were to do

everything it said in the curriculum in terms of art talk, our kids would be coming out of high school with a Ph.D. in art theory."

"So what really is the place of DBAE in your program?" I asked.

"In many ways it's great," she replied. "It woke a lot of us up because basically as a group of art teachers, we were very production oriented, you know? We really weren't spending enough time, energy, or effort on aesthetics, art criticism, or art history. But still, I think that making art is the heart and soul of the art program. The way I see it, aesthetics, art criticism, and art history should serve production. I suppose that's partly because of my background and the fact that I feel more comfortable in that area. I get a little nervous about some of the art talk and feel like I have to work at it more."

"But I saw you do a lot of really good art talk activities today," I countered.

"Well, I guess those are changes that I made sure I put into my teaching since that emphasis has been brought forth. And I definitely think it improves the art program. But the most wonderful thing about art is making it, getting your hands in there and doing it. That process involves so many wonderful opportunities for the kids, especially in forcing them to make decisions, helping them to realize there may be more than one right answer to a problem. Those are things they can carry across to the rest of their lives. So I get a little nervous in the curriculum-writing sessions when we keep talking about the other three disciplines. I have to keep saying to them, 'Isn't production important here? It seems like when we start writing curriculum, it has a tendency to get lost.' Their response is always something like, 'Oh, well, we know you'll produce art anyway.' But I don't want production to get lost in all of this."

"In actual practice, I'm not too worried that it will, though," she continued. "Nobody ever comes around and watches us—watches what we teach. Last year I had to be evaluated, for example. The Dean of Women spent fifteen minutes with me one day, ten another, and then we met once. And that was big. So no one is coming around saying, 'Well on page thirteen of your curriculum guide it says you will address such and such, and I see no evidence of that.'"

"So adherence to National and State Standards and benchmarks and to your local curriculum is pretty much a voluntary thing?" I asked.

"I think so," she responded. "Maybe I'll be surprised, now that we've rewritten it [the local curriculum] again, and we'll all start doing exactly what it tells us. But think what a chore it would be really to enforce it! They'd have to hire someone full-time just to be in charge of making sure art teachers were teaching what they're supposed to. But the point is I do try to incor-

porate art talk as required in the curriculum, and I do think it's valuable, but production is and should be the center of the art program. I mean that's how I got hooked, and that's the hook I use." *her philosophy*

The Making of an Art Teacher

importance of early exposure + positive exp. in art is important

"Talk about how you got hooked on art," I said.

"Well, when I was in third grade, in Grand Island, Nebraska, my art teacher—it was either my uncle or my mom—put one of my drawings on the bulletin board in the hall. My uncle taught third grade and my mom taught kindergarten, but also came around to all the classes as the art teacher. Anyway, I was so impressed that I'd had this big success through art that from then on I knew I was going to be an artist. It was a Lutheran school, and I copied this picture of Jesus in the Garden of Gethsemane, praying, you know? I copied it out of one of our books of Bible stories.

"Anyway, so when I got to junior high school I took art and then in high school I took all the art I could take. Then I went on to Hastings College, which is in Nebraska also. It's only about twenty-five miles from my hometown. I went there because we had one of those college open house nights where representatives come around from all the schools. Well, I went to the one from the University of Nebraska and they were talking about all the things that you take, and I asked when would I get to take art classes. 'Oh you have to get all your core classes out of the way first. You wouldn't be taking art for a couple of years.' I said, 'the heck with that!' Then we went across the hall to Hastings College and they said, 'Well we could probably even give you a scholarship in art. If you want to take art you can take art right away.' So I went. It was a four-year liberal arts school. And I majored in art.

"Then at that point I thought I needed to start thinking about a career. My mother had always been a teacher, and in a way I saw that as sort of a negative thing. I kinda liked to have Mom around home at night, and she would forever be having to go off and take another class to renew her certificate. She had a lifetime certificate before I was born, then she took a few too many years off and lost it, so she kept having to get more classes. I said, 'I don't want to have to go to school for the rest of my life.'

"But Mr. Maxwell, my art teacher, had been a commercial artist, and he would say, 'Well, unless you're really the top guy on the pole, you end up just doing other people's busywork. You're not really making art.' And it just didn't seem that there was a lot of talk about other kinds of art careers [than teaching] at that point. You were a teacher or you were an artist, which seemed like a risky approach to life. Or you could be a commercial artist, and

the possibilities in commercial art just kinda got lumped together. It didn't seem like anybody ever really explained all the possibilities that exist there to me. So I said, 'I guess I'd better be a teacher.' So I took the required teacher training courses and did student teaching at a middle school in Hastings. That was my teacher training.

"One of the other teachers there at Hastings College, Gary Colter, was pretty influential in terms of my next move. He said, 'Well, you don't want to go out and teach, yet. You want to go to graduate school.' He had friends who were teaching at Fort Hays, Kansas, State University, and that's where he had come from. Bronze casting was a big deal there and he convinced me that that's where I should want to go, and he could get me in with them. So, much to my father's dismay, I went back to school. I decided my mom didn't have such a bad idea after all about going to school all the time. So I went to Hays on a graduate assistantship, taught a couple classes on that and got a degree, an M.A., in bronze casting. Well, really, in art.

"So then the honeymoon was really over," she continued, "and I had to go out and do the real thing. With no experience under my belt I started looking for teaching jobs. I had an interview with Wichita Public Schools and was hired to teach at Wichita High School Southeast. It was a big school. There were three of us in the art department. I taught there for two years. Then my husband wanted to go to graduate school at the University of Oregon so I taught for a couple of years in Junction City, Oregon, at their junior high, then I did get a job at Colin Kelly Junior High, in Eugene, for a year. Then we came to Great Falls.

"The first year here in Great Falls I had to work in a little gift shop. There were no jobs. But during the year I met the art supervisor and I got my little fingers in the pie and I found the people to be in touch with. You know, those first few jobs were so simple. I really had an advantage because even the first one I had the teaching experience from graduate school. And I had a master's degree and experience from then on. But by the time I got here, there was starting to be more and more competition for teaching jobs, and fewer and fewer jobs available. But I had an advantage in experience and training and I would call the personnel director weekly. Finally I went away for a couple of weeks in the summer. When I came back the director said, 'Well, where have you been? I've been trying to reach you. I've got this job. Do you want it?' Of course I did.

"That started me out at Great Falls High School. It was in 1974. And I taught for seven years. At that point they were offering sabbaticals in this district—they don't have those anymore, unfortunately—so I took a sabbatical. I decided that it would be fun to do a degree in fibers. I really fell in love with

it and I wanted to have an M.F.A., and I wanted to stay another year, but there was no precedent. So when I called and said, 'Can't I stay here the extra year?' they said, 'Oh no, you have to come back. Or you have to repay your sabbatical.' That was the policy. So I came back for a year. But as soon as I got here I started applying for a leave of absence, to go back and finish that degree because I knew if I waited too long it would be less appealing and get harder. This was also at the time when the population was declining in Great Falls, and the district had closed a number of schools. In fact, they laid off eighty teachers in one year. So eventually I convinced the school board, went back the next year, and finished my M.F.A. in fibers."

"So how effective was your teacher training, overall?" I asked.

"I'd say basically I learned everything on the job. When I was in school it was the Abstract Expressionist era. Nobody really talked about why they did anything, or how they did anything. If it's good art it'll stand on its own. And it was a small school so there wasn't a lot of pressure. There wasn't a lot of critiquing. I mean I took art history classes, and all the standard stuff, and in the education department, of course, I had to take psychology and tests and measurements. But they didn't teach you how to teach art. No, it was all kind of haphazard, like, well, I guess we'll do this or that project now."

Rewards, Frustrations, and the Value of Making Art

"What's the most satisfying thing about your job?" I asked.

"The kids," she replied. "And especially the senior studio kids are the best thing about it. They'll often come back and tell you where they've been and what they're doing, and you just really develop a strong relationship with those kids, and seeing what they're doing."

"How about the most frustrating thing?"

"I suppose the interruptions, like that come in the form of changed schedules that throw things off. Or like today I got two new students. 'Here we are three weeks into the year, and where have you been?' I asked them. 'Oh, I don't know, nowhere.' So they have nothing, a zero. Or interruptions from the administration. We complain about it at the department head meetings, and they do try to work on that. Like if somebody phones for me, they put a note in my mailbox. But if somebody phones for Sally in my class the runner brings a note for her, even if it's only Mom saying, 'I decided we can't go shopping after school today.' So I'll be talking and I'll have to interrupt what I'm doing to deliver this message. Just dealing with that kind of thing is frustrating.

"I guess another thing, as far as students are concerned, I'm not great at confrontations. I don't like it when they don't just do what I say to do. I don't like going through with the warning steps and following through with that. Consequently, there are times when I get sloppy about it. It's an avoidance pattern and that's frustrating to me. Then if they pick up on that I'm sunk. Then they can overrun me. And I don't like that, either, so I really have to work at following through [on discipline]. Seems like when I started teaching people would say, 'Oh, those kids, they've gotten so much worse.' Well, they haven't gotten worse, but I think there are more kids now who will test you, just in those little ways. They aren't really bad but they'll just kind of torture you, if you let them, by talking when you're trying to talk or not getting on task, and that kind of thing."

"How would you change your life at work to make it more ideal if you could?" I asked.

"Well, I'd certainly give us more money for the budget. Like the fund-raising thing. Shoot. I certainly didn't take a class in fund-raising in college or anywhere else. It wasn't something I set out to do. It would be nice if financial support was actually moving up with the cost of the materials.

"The elementary program is doing something the last couple of years that I think would be fun to do," she continued. "They're doing a kind of a theme-based, integrated, team-teaching situation, where they plan units and have feedback from each other. The program works this way: each [elementary] teacher will contact one of the art teachers and say, 'Well, we're doing a unit in fractions. Can you come up with an art unit that will go with that?' So the three art teachers get together and brainstorm possibilities, develop the unit, and teach it. And they might even do a video so other teachers can use it. Sometimes I wish we had time to do something like that in the high school.

"Anyway, more time to communicate with other art teachers would be dandy," she continued. "And it just doesn't happen. We all have levels of expertise and it would be so neat if you could come over and teach my unit on such and such and I in exchange could go to your school—that kind of thing. It just doesn't happen and there we are even right next door to each other, Jack and I, and we don't do that."

"So there's really no mechanism for communication, then?"

"Well, we have art staff meetings once a month, but there's always a lot of business to attend to."

"So are you a practicing artist?" I asked.

She pretended to cry and said, "Yeah, well, I'd like to be a practicing artist. You're not left with a lot of energy for making art after teaching. With a degree in fibers you might think that I would weave or something like that,

but I do basically mixed media kinds of things. There are times when I'll shift into high gear when I have a deadline and get a whole bunch of stuff done. Like for an exhibition I'll get a whole bunch of stuff made, but if I don't have that pressure, you know, the daily routine, the house, the job, and so forth take over and I don't get as much done. The district as a whole does have a philosophy that being a practicing artist is a criterion for being hired. You have to show your portfolio. I don't think that all districts do that."

"So," I asked her, "would you do it all again, I mean be an art teacher?"

There was a long pause before she said, "Well, I think I would. I just can't conceive of anything else. Like I said earlier, I'd have to be doing something with art. And I think it's a very rewarding career, not financially, but in other ways. Especially here, the art staff is real supportive of each other and that creates a wonderful built-in community that would be hard to imagine living without. I think being as isolated as we are here in Montana, even at the state level, art teachers have a fairly strong community. That's a wonderful benefit."

She thought again for a minute, then added, "Oh, I suppose it would be great to just be an artist. I mean if I was just going to really dream, that would be wonderful." She was silent another few seconds then added, "But then, if that's what I really want, why am I not saying I'll just retire and be an artist? Well, because I know that's not an easy road either. . . ."

Profile: Jean Price

Current Position: Art teacher and Art Department Chair, Great Falls High School, Great Falls, Montana.

Education: K–12 in Grand Island, Nebraska; B.A. in art from Hastings College, Hastings, Nebraska, 1965; M.A., Fort Hays State College, Fort Hays, Kansas, 1966; M.F.A., Southern Illinois University, Carbondale, Illinois, 1984.

Practicing Artist: Price is currently making mixed-media altarpieces/installations, and wishes she had more time to make art. She thinks it's important that an art teacher be a practicing artist as the primary means to inform his/her teaching. "Even though I don't have time to produce many finished products, my own art making keeps me in touch with the processes, broadens the scope of my ideas, and allows me to share with my students the excitement that comes from making art."

Teaching Experience: Twenty-nine years. Wichita High School Southeast, Wichita, Kansas, two years. Junction City Junior High School, Junction City,

Oregon, two years. Colin Kelly Junior High School, Eugene, Oregon, one year. North Middle School, Great Falls, Montana, one year. Great Falls High School, Great Falls, Montana, twenty-three years.

Current Teaching Load: Six periods of high school art including a two-period advanced placement class, three periods of art workshop (art survey), and one period of crafts.

Extra Professional Duties and Activities: Price serves as department chair for the art faculty and says, "I get a dollar a day extra for that and I store away the extra income and do grand things with it. Other department heads get more pay and a duty-free prep period. It depends on how many people are in their departments. I've always said that's not a fair way of determining it because I often have to do far more paperwork than some of them. I mean all the supply orders and all the exhibits that we deal with. The teaching day is supposed to be five teaching hours, one prep, and one duty. The duty is usually hall monitoring or a study hall, the cafeteria, or outside duty. But functioning as the department head fulfills my duty obligation. My colleague Jack Fischer runs our art gallery as his duty. And Dave Rothweiler runs the darkroom as his duty. So we're sort of out of the normal duty loop. But all of us in the entire building, including administrators and counselors and everybody, take turns at what we call outside duty after school. They give you a walkie-talkie and you go hang out in the parking lot for fifteen or twenty minutes till the grounds clear. I don't think I've ever really pushed the button on the darn thing to ask for help so I'm a little nervous about whether it really works. Like, 'Hello in there. Big fight and I'm not going near it.' But that's for a week, and last year I did have it twice. It goes around alphabetically. So everybody gets that."

Current Salary: "Well, I'm at the top of the salary scale. Fortunately I didn't lose any years when I came in. They would take up to five years and that's what I had, so I didn't lose anything. I make right about $40,000."

5

Maria Sarduy

A South Florida Perspective

As I drove through downtown Hialeah, Florida, looking for Ernest R. Graham Elementary School, signs said: "IMPRENTA: Mazon Printing"; "Cafe Cubano—Carniceria"; "Comidas Tipicas Ecuatorianas—Open 24 Hours"; "Funerales, Pre-Adjustados, $25 al Mes"; "Servicio de Beepers, $1.99"; and so on. The lengua franca in Hialeah is Spanish. The population is almost totally Cuban American. And unlike next-door neighbor Northwest Miami, Hialeah is clean, safe, and prosperous. There are lots of lower-middle-class houses near downtown and lots of older cars, but also a discernible sense of order and pride. People tend to make eye contact and it's not unusual for them to smile, whether they know you or not.

Florida's Largest Elementary School

Ernest R. Graham is the largest elementary school in the state of Florida. It

looks a little like a bright fort. It has a large, steel-beamed, decorative structure painted bright yellow at the front entrance and a secured, red-fenced, walled compound. A large, red, steel gate serves as the primary entrance. Above the gate it says that Graham Elementary is a "Five Star School, 1997–98." Inside, the design is standard contemporary South Florida, with pods of rooms connected to other pods by covered walkways. The office, which is just inside the gate, feels clean, bright, and efficient and was abuzz with activity when I arrived. Eight or ten women at various workstations were conducting the school's business in Spanish. A receptionist looked up at me, sized me up as an English speaker, and said,

"Yes?"

"I'm here to observe Maria Sarduy," I said.

She asked another receptionist about "a Mrs. Sarduy." They looked her up in the book and then directed me down one of the palm tree–lined, covered walkways to her room. I thought it was pretty odd that they didn't recognize the name or know the whereabouts of this year's Ernest R. Graham Teacher of the Year. But then, there are a lot of teachers in the school.

"How many students are in this school?" I asked, when I finally found her.

"We have 2,300-and-something—and growing," she told me. "We're far larger than a lot of middle schools and some of the high schools. And with little kids, it's ten times as crazy."

"Why so large?" I asked.

"I don't know," she said, "but I'm assuming it's because they had no other choice. They had all these kids and they know more are coming."

"This community seems to be mushrooming," I agreed, pointing to the new houses just across the street.

"Yeah, they're all over," said Sarduy. "And that way too," she said pointing in the other direction. "And they're still building."

"Where are all the people coming from?" I asked.

"They're coming from different places. Six years ago when [hurricane] Andrew hit, they started moving north, from Miami and from Homestead, especially. I've got a feeling that's still happening. But you also have new people arriving from Cuba—the families that were living with their relatives but are now ready to go on their own—and they need a low-income, not-too-expensive rent, and this is perfect. A lot of the parents here speak English, so I'm assuming they've been here a long time. Other parents don't speak any English, so I know that either they recently arrived from another country, or maybe they arrived a couple of years ago, and now have been able to finally buy their own house."

"Does it work to have the school so big?"

"The little kids get lost sometimes, so I think it's too big. I prefer the smaller environment, you know, where you go into the front office and say a kid's name and somebody there can associate it with a teacher. Here they have to go looking for the ID number, 'Let's see, where are they at now? Which teacher are they with?' "

"They seem not even to recognize all the teachers' names," I said.

"I don't even recognize all the teachers' names," said Sarduy.

"How many teachers are in this school?" I asked.

"A hundred, maybe? I see teachers pass me by in the hallway and I have no idea who they are. So you lose that family kind of environment that's nice, and I think, necessary for an elementary school. But the sense of family is a strong community value here. In the Hispanic community family is way up there. But you lose some of that at this school because of its size."

"Do most of your students speak Spanish in their homes?" I asked.

"Yes, they do," she replied. "I'd say maybe 85 percent."

"Are all the Spanish-speaking kids Cuban American?"

"We have about forty different countries represented in the school, from Mexico to most of the countries in Central and South America. Then we have, like, 1 percent Asian American, and Anglo [American] might be another 1 percent. So we're mainly Hispanic and of the Hispanic, it's predominantly Cuban American. But there are definitely others. You get a very Latin feeling as you walk through the hallways."

"And you say the parents are really involved in their children's educations here?"

"I'm Hispanic," said Sarduy, "so I admit to our ways. We're just very emotional sometimes, and I'm not sure but sometimes we talk too much, and we're very overly concerned, especially about our children. And I'm guilty of that. But it's good I suppose," she continued, "that parents are concerned like that.

"I was in an inner-city school for seven years and it's a very different situation to get parents to come to school—to show any concern, good or bad, it's like pulling teeth. A very different story. There you maybe had no parent to go to. I mean when I was pregnant at the other school I had a chair thrown at me by one of my emotionally [disabled] kids. You know, on purpose. A chair! And I had my room destroyed. Twice. A child decided he was going to have a fit and kick all the paint bottles down. I mean crazy things like that. But the kids are really well behaved here."

"Do you think that's partly due to the fact that the community and families are intact?"

"Absolutely. It's a very, very important thing in our culture," said Sarduy. "If I do have a discipline problem, all I have to do, usually, is tell them that I may have to call their homes. They don't want that. In the other school if I said I was going to call home, they'd just shrug their shoulders. Home? There's nobody there. They probably live with another family member. Not even a parent. The parent might be who knows where, so they didn't care if you called home. They couldn't care less. Here, you say home, and they'll react. They'll react."

"So what's your schedule?" I asked.

"I usually get here—on the good days—at 8:15," she said. "But if we forgot our kids' lunch boxes and we have to drive back ten miles, or the traffic is bad, it may be 8:30. But I have my planning period at 8:30, so that's good. I don't see the first kids until 9:00."

First Period *Process begins*

And with that it was, in fact, 9:00, time to see the first class. A group of sixth graders was standing in a neat, long line in the breezeway outside the art room door. Dressed in one variety or another of the school uniform—white, green, or yellow shirts, pants, and skirts in a variety of solids, stripes, and plaids—the students filed in.

39 students

By the time the students are all seated there are thirty-five of them at nine square classroom tables, with two more sitting at a supplies table at the end of the room, and a thirty-eighth student at a computer station off to the side. The room is full. Way full. It's not a big room, but it is well organized and has a big storage room opening off on one side. One student, number thirty-nine, is still standing.

class mgmnt

"You'll be a floater," says Mrs. Sarduy to her. "When someone is absent you'll take his or her seat." Then to the group she says, "Hands up, please, if you have a computer coupon. Keep them where I can see them. OK, Jorge, you're first. Don't forget to set the timer. Any special artist passes? OK, Mercedes, looks like you're the only one. Fifteen minutes."

As Mercedes moves over to the special artist station full of fun things to do, Mrs. Sarduy alerts the rest of the group: "First of all, I need eyeballs up here." Not everyone complies.

"I'll wait," she says. A couple of seconds later she has everyone's attention, and says, "Good. We need to finish our pop art self-portraits today. We're at different places, so if you're behind, you really need to work hard today. Let's remember. What are we trying to show in the four different portraits?"

"Color," says a girl.

"Why?" says Sarduy. "What was Andy Warhol trying to show with color in the portraits we saw?"

"Feeling!" says another student.

"Great!" says Sarduy. "What else?"

"Pattern," says another.

"Shapes," says yet another.

"Good," says Sarduy. "Those are the elements we're working with then, to show the four different emotions we've chosen. If you're far enough along today, we're going to start to mount the portraits. See that black paper? We're going to mount them on that. To enhance your effects, you can mount them right side up, upside down, or overlapping, but don't do anything that confuses the emotions you're portraying. OK, I'm looking for helpers who are sitting straight and paying attention."

Everyone is, and Sarduy picks a couple of kids to pass out glue and markers.

"Do you want the narrow markers, too?" she asks.

"Yes!" they all reply.

"Jeanette, can you pass out the markers? Jose, will you give mirrors to anyone who still needs one, please?"

As she passes out the portraits-in-progress and the children lapse into art room chatter, I note that about half of it is in Spanish. After a few minutes it gets a little loud.

"Will I have good news for Mrs. McCann today or not?" she asks. *class mgmnt*

Immediately it gets quieter. The children work on for a while, and about two thirds of the way through the period, Sarduy takes roll. As she calls names (Sasha? Frederick? Geraldine? . . .) and students raise their hands in response, she takes the opportunity to comment on and encourage their work. — *affirmation*

"Geraldine, you might want to develop more background pattern. Orlando, that's an interesting arrangement. Maybe if you moved this one over there it would work even better. Brown table, I really like the way you're working." *positive critique*

A timer bell sounds and she says, "Oh, it's time to clean up." The children start cleaning up with a bit of protest. They want to keep working. *process*

"Fuscia table," says Sarduy, "I like the progress you're making. Green table—everybody!—I'm going to start counting and I want you to be cleaned up when I reach ten. One, two . . . three. . . . Green table, I'm at eight-and-a-half, nine . . . When I get to ten I want to see clean tables and frozen bodies. Ten! OK, I like the way a lot of you arranged your portraits. I don't know about taking you over for the special project next Thursday, though. It was a little rowdy in here." *class mgmnt* — *behavior*

"We'll behave Mrs. Sarduy! We promise!"

"Well, we'll see. I'll let you know. OK, if you were quiet today and did *behavior* your work and haven't received a special artist pass or computer pass yet, *incentives* raise your hand. If you were noisy, don't bother raising your hand."

She looks around at the raised hands and passes out a few of the treasured passes. Brown table gets the bulk of them.

colored "OK," she says, "orange table, line up. Brown table, line up. Fuscia *table* table."
class
mgmnt The last table to get permission to line up, quiet now, is green table.
"Reynaldo! Stay in line."

The Intercom

First period files out of the room and immediately the next class—a fifth-grade group—files in, and it starts again.

"Let me see your hands if you have a computer or a special artist pass," says Mrs. Sarduy.

As she's making her presentation, there's a very loud beep from the intercom.

"Hello?" says Sarduy.

"Yes ma'am, can you hear me?" says a voice from the speaker. (There's no apology for the interruption.)

"Yes."

"We're just testing the P.A. system." (There's another loud beep.) "Please tell me if you can hear the national anthem. We're testing it for parents' night tonight."

"OK."

Mrs. Sarduy waits about a minute. There's silence on the intercom, except for a loud beep about every fifteen seconds, so she starts into her lesson again. Incredibly, she talks right through the beeping and keeps most of the children's attention.

Another voice interruption: "Did you hear it?"

"No. We hear you speaking but we didn't hear the 'Star Spangled Banner.'"

The national anthem can now be heard very faintly over the P.A. system. Sarduy keeps on with her presentation.

"Excuse me," says the intercom voice, "How about now?"

"We hear it very faintly." To the class she says with a smile, "They're experimenting with us, but we have work to do too."

"How about now?" says the intercom voice.

"Just very faintly," says Sarduy patiently, then says to the class, "Oh, I hope he didn't hear me just now."

"How about now?"

"No better," she says.

"OK. Thank you."

Mrs. Sarduy doesn't acknowledge the final thank-you, but continues to stay on track and keep her class on track just as she has throughout this incredible interruption. I can't help but wonder if any other class would be similarly interrupted. Was it because the art class is simply an eye-hand activity in the minds of the offending office staff, or would English and math lessons be similarly disrupted in the service of technological preparations for parents night?

Spanish Culture in the School

Sarduy taught the same portrait lesson to the fifth grade that she taught earlier to the sixth grade. Both are extended foreign language classes as will be the rest of Sarduy's classes on this day. Most of the kids in each of these classes have been together since kindergarten. They have language arts, math, and geography in English, but they also have science in Spanish and a Spanish language class as well as special Spanish-language activities.

"They like me to teach this class in Spanish sometimes, too," Sarduy told me, "but we have a lot to do today so I'm teaching in English." (I suspect that the English version was also for my benefit.)

I asked Sarduy to tell me about the extended foreign language classes.

"Well," she said, "Specially selected students are identified to participate by their teachers in kindergarten, based in part on knowledge that their home language is Spanish."

"How many kids are in the program?"

"One class per grade level. K through six. So about 180 kids. The classes are a little bit smaller than the others. Not in sixth grade though. It's a full house when they're here."

"I noticed," I said. "Did you speak English before you went to school?"

"No, I did not. I learned it as a little kindergartner, so I know what it's like for a lot of these kids. I was born in Havana, Cuba. After Castro took over, my family decided it was best to leave. So when I was four we left. We left during the freedom flights in December of 1968. So I started elementary school here, which is why I would think my primary language is English. Even though we always spoke Spanish at home."

"So you're a natural to teach the extended foreign language art classes.

Does either of the other two art teachers teach these extended foreign language kids?"

"No," she said. "I'm the only one."

After Lunch: Second Grade

"Kindergarten through first grade don't see an art specialist at all, is that right?" I asked.

"Yes, that's right," she said beginning to prepare for her afternoon classes. "Usually I have my morning classes working on one thing and my afternoon classes working on another, you know, because of the materials. The morning classes are older and the afternoon classes younger—second, third, and fourth."

As the second grade files in, one girl asks, "Is a female a girl, Mrs. Sarduy?"

"Yes it is. I know what you've been working on this morning!" she says with a smile.

The younger students are working on imaginary creatures in art. A couple of examples of previous successful products are taped up on the

visual directive board. There's also a list of production steps taped up: 1—color, 2—cut, 3—glue, 4—draw. Another list suggests possible content/components for imaginary creatures: wings, horns, stripes, spots, antennae, whiskers, fins, scales.

Sarduy begins with this second-grade group by saying, "I was told there are some imaginary creatures in the back who wanted to escape—who wanted to get away, but I told them they couldn't leave because they weren't done. So what do we have to do to finish them? Put them in a cage?"

The children laugh. "No," they say.

"What then?"

Goal for day "Finish coloring them," says one child.

"OK, that's step one. And step two is?"

"Cut them out!"

"Are you going to cut them out fast and sloppy?"

"No!"

Process "How then?"

"Careful!"

"That's right, careful. And I might even give a grade for how you cut. Besides, if you cut fast you might cut yourself. Mrs. Sarduy's scissors are very sharp. And what's the third step?"

"Glue!"

"That's right, glue. You're such a good class. This is one of my best classes!"

differential instruction

Sarduy talks differently to the second grade than to the sixth. She knows that what works with a second grader would sound patronizing and phony to a sixth grader, and she adjusts the content and tone of her presentations accordingly. She's expert at reaching each student at his or her own level. But one thing remained consistent. Sarduy acknowledged almost all of the classes I saw as the best at something or other. Maybe her consistent positive reinforcement and her ability to reach almost every child at his/her own level accounted in part for the fact that they *were* all her best classes.

"That's right," she continued, "You'll put just a few drops of glue on the back of your creature and put it either on the blue or the black paper. Because your creature has to be somewhere. If it's daytime, what color is your paper?"

"Blue!"

"Nighttime?"

"Black!"

context → *content*

"Underwater?"

"Blue!"

"Good, and there need to be other things to show where your creature is, too. What kinds of things might be under the water? Shells, good! Seaweed, that's right. What kinds of things might you see at night?"

She begins to pass back the partially completed artworks as she motivates the students and gives them ideas for content and structure: "Armando? Here you go. Patricia? These are absolutely the best creatures I've seen in the second grade! Thank you, green group, for getting to work so quickly and quietly."

"What should I do now, Mrs. Sarduy?" asks one boy.

She glances at his work to see how far along he is and says, "What's step two? Look at the board."

"Cut," he says.

"Uh-huh. By the way, if any of you have forgotten where your creature is, look again at the story you wrote about it. Remember, it's in the first line of your story. Remember, the background is as important as the creature. If I can tell where your creature is, you've done a good job." *background, foreground subject*

"Mrs. Sarduy, what's in the grass?"

"Class?"

"Bugs!" one boy shouts out.

"I want to see hands," says Sarduy.

He raises his hand and she points to him. "Bugs," he says.

"Good. What else?" And on it goes, as she moves around the room with the trash can, picking up the scraps from step two. She stops and holds up an image.

"Look here at Tatyana's creature. Where is it? Right. Outer space. What background features do you see that tell you that? . . ."

"What if my creature is too complicated?" asks Tatyana.

"You can make it simpler if you want." Then to the whole class, she says, "That's a good question. You all know, now that we've started and thought about it, you can even change your story a little."

Later, she told me, "There have to be criteria for these projects, like if I ask for three original buildings of your own in the collage, then I expect to see three original buildings. If I say there should be a notable skyline, then there should be a notable skyline. But, on the other hand, how could you stop them from being creative? How about if the kid doesn't want a skyline and wants the buildings to be seen from a bird's-eye view? I have to allow for that, too. That's his own personal creativity coming out. I can't stamp that out. So I have to be flexible."

Student centered "So you're trying to achieve a balance between your structure and their drives?" I asked.

"Yes. Because the problem is that there are some children who need structure and need the criteria to go by, because you know they're going to count, 'One, two, three, do I have what I need?' Then there's the child who may not even be listening because he already has a plan in mind. So I'm here in between and I have to cater to both of those children. So, yes there are criteria, yes, there are rules, but if it's appropriate, maybe there's not those rules for some kids, sometimes. On the bubble sheets I have to give them an A or a B, and so on. In my grade book I show a project grade for their product, but I also give an effort grade: 1, 2, 3. I can judge whether they were trying hard that day or sitting there asleep. In their conduct grade, if they follow my four little rules posted over there you're going to get an A all the time."

"Everyone listen!" says Sarduy to the class.

Jerrell has a question but is insecure and shy and stumbles through it. Mrs. Sarduy waits patiently, letting him frame and finish his question by himself. Finally he comes out with, "What if I, well, what if I can't cut too good and cut off my creature's legs?"

age approp skill "Don't worry," says Sarduy. "We can always perform surgery and tape its legs back on. It's important to cut slow and to practice cutting," she adds to the group.

"And remember," she adds, "these are *your* imaginary animals, not copies of Godzilla or some other creature you already know. These come out of here," she said pointing to her head. "I've never seen more creative crea-

tures from second graders," she adds, then goes on, "You can borrow elements from different places, different creatures that you've seen, but your animal should come from your head."

"Can it have three eyes?"

"Sure! That's what we're learning, that there's a difference between real animals and your imaginary animals. There's a difference between real and not real. Your animal can have as many eyes as you want." Turning, she added, "Isabella, you only have two minutes left at the computer. Black or blue paper, Mario?"

Later, I asked about the computer time she gave selected students. She told me, "Students who are productive and cooperative get a coupon to work on the computer the next time. The coupon is worth ten minutes. And there are also special artist passes. Those are worth fifteen minutes."

"I noticed that there was a timer at the computer. Do you set that?"

"No, they set their own timer, except for the second graders. I set their timer."

"So what do they do on the computer?"

"They either create art or they look at museums' artwork. Actually, I have three very wonderful programs. The little ones do art on the *Kid Pix* program. They get to paint, they get to draw, they get to stamp, do printmaking, they get to write, incorporate words into their art work, and we print it and have things to hang that look like that," she said, pointing to the bulletin board above the computer. "For the older ones I have another wonderful program called *With Open Eyes*, which is images from the Chicago Art Institute, and it has little games and puzzles for kids. They tour the museum and they can view the images and the can analyze the images, and play little puzzle games with the images, and it talks to them and gives them music and background on the works of art. Then I also have a *Fun with Architecture* program, which is building structures and things. That one came in very handy for the class that's doing architectural collages."

As she was telling me about the computer program a teacher's aide came in and asked to "borrow" some paper. This is another part of Sarduy's balancing act. During the course of an average day a number of teachers and students sent by teachers come in asking for supplies and/or advice. On this day I noted at least ten instances of this. But finally, the last period of the day, there was payback. Mrs. Ramos came in with a gift. It was flower seed packets: one for everyone.

"She saw your lovely mural out there and thought you were so inspired by nature that she'd bring you this present," says Sarduy to the class. "I'll pass

out one of these to each of you after we're cleaned up. I told you people would be impressed."

Why Teach Art?

After school, I asked Sarduy, "So why did you become an art teacher?"

"I really, really wanted to. I like kids and art, so what better thing to do? I took a road around it because of the pressure from my parents, but I ended up right where I started from. It's funny how people do that in life. But I know where, too, I don't want to be. Some people who are here may not know where they don't want to be, but I know where I don't want to be. So I'm much happier knowing that, and knowing that I want to be here."

"What's the most rewarding, satisfying aspect of what you do? What's best about your job?" I asked.

"Oh, my! That doesn't have one answer," she said. "It's rewarding to have kids understand concepts. It's rewarding for kids to look at their work and know that they like it. It's rewarding to reach children. Like Emile [who came in to show her what he done with a piece of seashell she gave him as a reward for doing well in class] who's a problem child with problem parents at home. That child is only happy in a couple of places in this school and this is one of those places. It's rewarding to have children come up to me in the hall and 'Ms. Sarduy! Ms. Sarduy!' and smile at me. It's rewarding when they bring their parents over and say, 'That's my art teacher! That's my art teacher!' It's rewarding when they come and see me after they're not my students anymore. It's rewarding when they think of you as more than just a person who teaches them a couple of things here and there, when they think of you as an important person in their life."

"What's the most frustrating, irritating part of your job?" I asked.

"Let me think about that," she said. "Not because I don't find a lot of things frustrating. I do. Well, I guess the thing I find most frustrating is when I have to sit down and do all this paperwork. You have to write out all your lesson plans and they have to correlate with this and that: the CBC [Dade County Competency-Based Curriculum] and the Sunshine State Standards. That's very frustrating. Everybody complains about that. It's for accountability purposes, but it's frustrating for me because I know what I'm going to do, I have a very organized plan, but I have to sit and write it all out and make it pretty for somebody to come and flip through it."

"How much of your time do you spend with that?"

"I spend a lot of my time with that. I use my planning period or even take it home sometimes because I don't have time to do it at school. That

takes away from time that I should be spending planning for or working with the kids. That's very frustrating."

"So, ultimately, who decides what you teach?" I asked.

"I decide what I teach, but I need to make sure the children know those competencies at each grade level. So we're doing a set of competencies at each grade level and a set of objectives for the different components. The components are studio, aesthetics, art criticism, history, and personal growth."

"So does the competency-based curriculum for Dade County come down from the National Standards?"

"I'm sure it's derived from the National Standards. But it's not modeled directly after them. CBC is unique to Dade County, because I remember when they were writing the competencies, I was a small part of that. We went from what we called Curriculart, our old curriculum, which had specific lessons, to this new one, which does not have specific lessons. It has standards and benchmarks. But there's lots of them. Lots and lots of them. Very complete, very thorough, very well thought out."

"But I get the feeling that for a seasoned professional such as yourself, this gets in the way rather than being helpful."

"Yeah. Writing it down and making it look nice for other people to look at who have no idea what I'm doing. Yes. That gets in the way. I'd rather spend that time preparing things for the children or doing something that's going to directly affect the children."

"Did you know it was going to be like this when you were in your teacher training program?" I asked. "How well did that prepare you?"

"It was good," she said. "Especially the classes I took with Clem Pennington. But teaching is one of those things where you have to find your own road, and you pick up things along the way and no matter what everybody teaches you, you still have to make your own way. There are lots of things you can learn that are theory, but at some point you come to making your own systems and creating your own way of teaching. So yes, those courses were helpful, and yes, they were good and I would rank them very highly, but ultimately you have to decide for yourself how you're going to do things."

"You learn on the job?"

"Yes. It's a learn-on-the-job type of thing. There's no teacher, I guess, who could say otherwise, because even those general teaching methods where they videotape you, there's no audience, no kids, and that's unrealistic. So they can only teach you so much."

Looking at my watch, I asked her, "When do you leave school? You must be getting tired."

"Well, teachers can leave at 3:20, but I never leave at 3:20. I don't know that there's anybody who does. Oh, wait," she said, with slight disdain, "there are some people who leave at 3:20. But," she continued, "I'm here until I'm done doing what I have to do. That can be 4:00 or 5:00, or on the days that I have my computer class, it's 8:30. Last night I left at 8:30. And last Tuesday we had open house and I left at 8:30."

"So what do you have to bring home to your mother-in-law for taking care of the children on computer class nights?" I asked with a smile.

"Oh, my mother-in-law!" she said, laughing. "She's the greatest person in the world. She's just wonderful. But you know Cuban families are very close-knit. They support each other and I expect to do the same for my grandchildren. I can't think of it any other way. That's just the way it is."

Profile: Maria Jarduy

Current Position: Art teacher at Ernest R. Graham Elementary School, Hialeah (Dade County), Florida.

Education: Everglades Elementary School, West Miami Junior High, Coral Park Senior High, all in Miami; B.S. in communications with a specialization in advertising, and minors in art and French, at Florida International University, 1986. "I wanted to do a fine arts bachelor's but my parents thought I'd never get a job that way. So I went out to work in the advertising world, and oh, my goodness, it wasn't good. The minors helped me when I decided that advertising was the worst thing that could ever have happened, and went back to take the certification courses at FIU. To keep both my French and art certificates I have to have twelve college credits every five years.

"I'm currently in the master's program in technology applications in education at Barry University here in North Miami. I feel that technology is going to take over soon and if we don't keep up with it, it's going to take us over and I'm not about to let anything take me over. So it was kind of like a twofold decision. I need to keep up. I need to learn. And this is something I should be incorporating into my lessons."

Practicing Artist: "Not now. I was. I love to draw. I love to paint. I like to make jewelry. But right now I don't. I just really can't find the time. There's no time. But it's OK with me because everything else that takes up my time I'm very happy with. There'll come a time again, though, when I'll make art. It's very important to be able to make art to teach it. Very important. I have a sketchbook I keep at home and that's just a part of me. Art teachers have to have art skills. It is so important. I can't tell you how important it is."

Teaching Experience: Ten years, three at Graham Elementary and the rest at Allapattah Elementary, both in Dade County, Florida.

Current Teaching Load: She has a total of twenty-one art classes during the week, six of which have only extended foreign language students and three that have only gifted students. "I have five classes on three days, then one day of four, and two classes on Wednesdays. Wednesday is our short day. We dismiss at 2:00 for teacher planning. So I have two breaks in the afternoon. I see almost 800 students a week."

Extra Professional Duties and Activities: "We have outdoor duty after school. We're assigned in groups and each group of teachers will get a week where, every day from 3:00 to 3:20, we have to be out there, keeping order. I was a museum educator in 1992 and '93 while I was at Allapattah, one day a week in the Artworks Gallery in the Omni Mall, where we always showcase student artwork. Outside of school, I'm a member of the National Art Education Association, the Florida Art Education Association, and the Dade County Art Educators Association. I was the secretary for two years, in '92 and '93. We'll also have an art club by the middle of October—after we look at the kids and see what they can do. The other art teachers and I select the best of the fifth and sixth graders—the most motivated and talented ones. We have special activities between 2:15 and 3:30 on Wednesdays. Really that's our planning time that we're filling with an extra duty that we don't get paid for, but it's OK. The kids are wonderful. We do things we can't do during class. We do higher-level projects, you know, maybe junior high school–level projects. And we really have so much fun!" Sarduy was Teacher of the Year at both Allapatah (1994) and Graham (1998) Elementary Schools.

Supplies and Expendibles Budget: "I don't have a budget, really. I order what I need, and that's it. Last year the order that came in took two trucks to deliver and we couldn't see the windows back there because of the boxes. It was seven pages of supplies this year. I didn't total it. I'm sure it was more than $10,000, though, because I ordered for the whole art program as well as for the classroom teachers. Out of that, the budget for art was maybe $4,000 or $5,000. But think about how many students we have, too. We're not talking 900 kids. We're talking 2,300 kids. I really try not to go overboard because I really understand that it's not good to spend too much money. And finally, after many years in the system, I have it down. I know the difference between the stuff that's cheap and yucky and no good and the stuff that's good, so I'm careful that way. And I have a very supportive administration. Dr. Smith is absolutely wonderful. She supports the arts more than anyone I've ever

seen—not just art but music and all the arts. She has this way of incorporating them into the whole school."

Salary: It's a little over $33,000 if I don't work the summer. That's with ten years of experience and a bachelor's degree. The master's, when I get done, will help me another $3,000 or so. If I work the six-week summer school session it's about $3,500 more.

"A beginning art teacher with a bachelor's degree in Dade County makes about $28,500. A master's increment is $3,000 per year, a specialist degree is an additional $2,000, and a doctorate is an additional $5,000. So there's advancement opportunity. But not much. Is it adequate? No, and I don't think it ever will be, because people, you know, in our society I suppose don't really value the job of an educator, and it'll never be adequate. We're down here, while all those other jobs are up there that are much less valuable, in my mind. It's very sad, but it's not adequate at all. Am I OK, though? Yes I'm OK because I want to teach art till I drop, so what am I gonna do? I'm not going to change careers because I want a higher salary. I do what I do because I want to do it, and what I get paid is what I get paid."

6
Gayla Buyukas

Teaching Art in an Urban School-to-Work Program

It's 8:09 A.M. at David Douglas High School in Portland, Oregon. The first-period bell will ring in one minute. Gayla Buyukas has been at work since 5:30 this morning, just like every morning. A slight, stylish woman in her forties, she stands before the class as they come in, ready to give her short spiel before they go to work. She's wearing a flamboyant, "arty"-looking floral shirt over another black shirt and black pants. She has on large hammered brass earrings and multiple silver bracelets. It fits. She's the jewelry teacher. A pair of red half glasses and a bunch of keys dangle from separate chains around her neck. The glasses she slips on to examine close work. The keys are to all the doors, cabinets, and closets in her domain. Because the keys never leave her neck, it's good that she's not too tall and doesn't have to bend over too far to unlock the doors.

The Jewelry Room

Except maybe for some vaguely East Indian–sounding music on the CD

player—probably a New Age raga from Wyndham Hill—the jewelry room has the ambiance of a workshop. School's been in session for about a month and Buyukas' Jewelry One students have already learned most of the basic jewelry skills. Some students are using ball peen hammers to tap, tap, tap (rather than incorrectly bang, bang, bang) metal pieces into shape. Others are holding jewelers' saws with the delicate blades straight up and down, not applying too much pressure, patiently letting the delicate blade do its work. Some students have clamped their jewelry-in-progress onto wooden table-edge frames, smoothing corners and blade marks with small jewelers' files. Still other students are at the noisy, belt-driven buffing wheels, polishing almost-finished projects. They know to hold the piece firmly against the bottom of the buffing wheel so, if by chance it gets yanked from their hands, it'll be thrown harmlessly into the metal cage rather than out into the room. At another set of stations, students are lighting blow torches, adjusting the flames to the correct blue-hot temperature, and soldering pieces of their artwork together. They know how to get the solder to run to the heat. Across the room, students are using either the big belt-driven drill press or the little handheld Dremel tool, depending on their needs, being careful to have first made an impression with a metal punch, so the drill bit won't wander.

According to Buyukas, about half of these students were placed in jewelry by their counselors simply because they had no place else to be. Some are brilliant, but a large portion are what are called "merge" students, those with low intellectual abilities. Yet here they are, confidently, competently, and calmly using hammers, saws, and files, running blow torches, belt-driven buffers, and drill presses. No one's getting hurt. And everyone is having at least a moderate level of success in making good-looking, well-built jewelry.

"It's like running a shop," Buyukas told me, and sure enough, during her spiel to the first-period students, two guys in blue work shirts (with their names above the pockets) come in and ask about some gas parts. She interrupts her lecture to get them started repairing a soldering station. They're discussing the options a lot louder than necessary, with little or no concern that she's in the middle of her presentation. It's the blue-collar, we've-got-work-to-do sensibility. She simply has to talk over them. She needs the gas repaired.

Mandates, Mandates

In some sense this workmanlike environment is apropos and symbolic of larger realities at the high school. David Douglas High School is a school-to-work high school. That is, students are trained to go immediately into the work force upon graduation rather than continuing on in higher education.

It's an urban school on the east side of town with a proud history and a good reputation, formerly an academically oriented school, which has made a successful adjustment to changing demographic realities. The David Douglas School District is a one–high school system with two middle and eight elementary schools that used to be in the eastern suburbs, but has become part of the urban inner city. The racial mix is 80 percent white, 8 percent Asian, 5 percent Hispanic, and a small number of black kids and immigrants from Eastern Europe. The high school used to have about 3,000 mostly college-bound students, but now has less than 2,000 students, only 20 percent of whom will be going to college.

David Douglas' reputation as a school-to-work program is seemingly equal to its former reputation as a college-prep school. If numbers tell any part of the story, certainly the art department shares in this success. There are six art teachers on staff in the high school. That's up from three a mere four years ago. As Art Department Head Ron Linn tells it, "For the last three years before this one, we added an art teacher every year. As I get out in the community and talk with other art teachers, it's simply unknown to have six full-time art teachers in a school this size. Simply unknown. Administrative support for art is remarkably strong."

Maybe that has to do in part with how well the program is integrating the new State of Oregon standards programs, called CIM, for Certificate of Initial Mastery, and CAM, for Certificate of Advanced Mastery. CIM is a program that actually extends all the way from kindergarten to the sophomore year of high school. There are benchmarks at the third, sixth, and tenth grades designed to measure whether students have achieved the required standards at those levels.

According to Ron Linn, "At the high school level the difficulty is that in the lower grades the students are passed along. Whether they meet the standard or not, they're still passed along, and by the time they get to their sophomore year, they very well may be deficient. They can move on to their junior year without passing their CIM but they can't graduate from David Douglas High School without it. Eventually," he continued, "this will be the case in all of Oregon's public high schools, but not all have adopted the program yet. Anyway, in our case, it could be that [students] have to work on their CIM all the way through high school, if they haven't completed the requirements earlier."

The possible negative implications of that for elective courses such as art are obvious, which is why CIM requirements have been integrated into the art classes taught at David Douglas High School.

And after CIM comes CAM, which is directed mostly to juniors and seniors. The Certificate of Advanced Mastery track is very similar to a college

major, according to Linn. Students declare what CAM strand they'd like to follow and their course work is particularized accordingly. At David Douglas High School there are six possible CAM strands: Arts and Communications, which is the umbrella for the visual arts classes, Human Services, and four others. The "real tragedy" of CAM, according to Gayla Buyukas, lies in requiring students to pick a direction, foreclosing on all others, at age fifteen. This is a problem because the requirements of a particular CAM are such that there may not be time or room for students to explore anything outside their chosen area. Nevertheless, students are channeled into one strand or another. As an example, all the Arts and Communications students take certain core classes such as the Arts and Literature class, which also counts for their English credit, plus classes they choose in visual arts, theater, music, and the humanities. If students complete the CAM requirements with a C or better, they not only graduate with a high school diploma, but also with the CAM certificate.

Individual schools in Oregon have the option of pursuing additional goals under the CAM banner if they so choose. An important additional goal at David Douglas—the most important goal as Gayla Buyukas sees it—is to encourage students to be self-directed learners. Initially, self-directed learning was a component in the state's CAM plan too, but Buyukas says some people in the state found the idea threatening.

Said Buyukas, "They felt self-directed learners might advocate against a particular religion or belief or philosophy." Ever a diplomat, she was careful to avoid saying that self-directed learning was torpedoed by the Religious Right.

Then there's the PASS program. PASS, or Proficiency-based Admission Standards System, is an initiative of Oregon's higher education system. It consists of the basic proficiencies incoming students need to demonstrate to be accepted into the state's colleges and universities. In addition to CIM and CAM, David Douglas also is working toward integrating PASS into its curriculum.

The faculty members I spoke to in the high school all felt that the goals of the programs and even the programs themselves had individual merit, but also agreed with Ron Linn's assessment that with all three competing systems in place at once, "It becomes hard to see the target. It's hard to see what you're shooting for, because if you're teaching to PASS requirements, you might not be meeting CAM requirements and vice versa. It's difficult to keep each program's goals in focus, and to switch your focus as often as you're required to. It's hard to focus on CIM and CIM kids and CIM tasks and keep your CAM programs going too, let alone thinking about PASS. I only have so much

energy before and after school and within my prep period to get all these extra things [integrated with] the curriculum I'm already doing. We're trying to integrate all of it, but it hasn't happened to the degree it should for people to feel comfortable."

Buyukas adds, "the problem is that I'm teaching to all these concepts anyway, [and these state mandates] feel like they're just an added layer of bureaucracy, tasks added onto what it is that I really need to do." But like her colleagues, she does her best to integrate state requirements with her own sense of what teenagers need to be successful adults, in art and in general.

If students are not in the Arts and Communication CAM, their arts choices are framed as support classes rather than as core classes, making the politics of curricular integration especially intricate. In one sense, according to Buyukas, reading, writing, and arithmetic are still core, and all other courses are important (or not) relative to how closely they are designed to support this core of education. So a key to maintaining enrollment in art is to support the core subjects.

"For example," says Buyukas, "It's a good idea to frame 2-D and 3-D design as support tasks for math. Or if you were doing color theory, it could be a support task for science." In another sense, however, the school-to-work agenda really favors the skill-based subjects such as art, even in the context of state mandates and programs. According to Buyukas, raising standards through focusing on skills that can be directly applied is a particular strength of art. And beyond that, she says, "It has certainly been shown that students who have engaged in the arts do better on their SATs, at MIT, and at the business school at Harvard."

A Role for Art

"OK," I said, "So art can be shown to be an important support subject. But isn't there some value in what art teaches, beyond what it does for other subjects?"

"Well," she said, "It's been shown to have benefits for students with neurological problems, just to achieve normalcy; it's been shown to engage multiple different processes in the brain, from basic conceptualization of spatial relationships to technological aptitude. That's one thing I know."

During Buyukas' prep period we walked 200 yards, passing an enclosed pool/gymnasium and self-contained theater, to the other academic building where she was to conduct a practice job interview with a CIM student. As we walked, Buyukas noted that she agreed to this meeting as her extra duty because the request for interviewers came across on her e-mail several times

and she felt like they weren't getting a response. She has a strong social conscience.

Like many of her colleagues in this school-to-work environment, Buyukas' ties to business are strong and frequent. She told me as we walked that in conjunction with partners from industry, staff in the Tech CAM are gearing up to develop a monorail between the two academic buildings, with substantial student input. If that project is a success, the next undertaking will be to develop a gallery and frame shop in conjunction with the Arts and Communication CAM in which students will frame artwork for the community. Also, in her graphic design program last year, Buyukas had her students design what was, to her knowledge, the first school-to-work logo produced for a major corporation anywhere in the United States. The design contest, sponsored by the northwest regional office of McDonald's, was a required part of her graphic design curriculum. McDonald's presented David Douglas High School with a $500 annual scholarship in perpetuity in the winning student's name. According to Buyukas, the winning design, by student Emily Bartow, may be used nationally in the future. The other eight finalists had their designs put on McDonald's tray liners.

Says Buyukas, "The two women I worked with from McDonald's were extraordinary in their sensitivity to the academic environment and to student needs. Everybody was rewarded in some way or another. Nobody went away without something in their portfolio, and it is the first monetary art scholarship that I know of for David Douglas Schools. So it was a very rewarding experience."

From Student to Teacher

Buyukas came to her teaching job in Portland with an M.F.A. in metals from the University of Oregon, in Eugene, about a hundred miles to the south. But her childhood was spent farther south in Sacramento, California, where her mother was "second in command" in the California public school system for a number of years before her retirement.

She grew up around art. Buyukas' grandmother was a doctor who worked with Albert Schweitzer in Cameroon and collected African art, most of which was given as gifts in return for medical treatment. Much of that art eventually ended up in her mother's home. Buyukas says her mother was "an extremely creative person, very vivacious, very expressive, very artistic in her own right, and our house was filled with these African artifacts. My house was really an African experience," she continued. "I mean everywhere you looked were these artifacts that were so much a part of my mother's life. I

learned to enjoy their colors, the greens, the browns, the earth tones, and the repetitive patterns. Some of the batiks were hundreds of years old, and the whole process of totems and totemism was fascinating to me. I have a heart or a kidney or something. I don't know if it's from a person or an animal. My mother has seen both.

"And my dad," she continued, "who was an associate prison warden, was an avid reader, historian, and political scientist. I'll never forget when I was sixteen and watching *Silas Marner* on TV, and he began to tell me, verbatim, what was going to happen. I asked him how he knew and he said he'd read the book. I asked him, 'When?' He was fifty then, and he told me he read it when he was fourteen. He has a photographic memory. My mother and father's love of reading, and the fact that we didn't get a TV until I was fifteen, made me an avid reader. Their love of reading and interest in life is one of their most powerful gifts to me.

"So," she said, "between the intellectual stimulation and the African artwork, I feel I was set on a certain course that's different from a lot of other people. I just love to learn. It's a hunger. I just love being a student. I could be a student in perpetuity."

Buyukas is just three months shy of two other master's degrees beyond her M.F.A.: one from Marylhurst College, in art therapy, and the other from Portland State University, in art education. She doesn't plan to finish either degree, but says she's still hungry for knowledge. "I went through this college bookstore the other day, and they really need to follow me with a mop for the drool," she said.

"But right now I'm most interested in my mediums, my art," she continued. "And that's the great thing about my job, is that I get to do what they [the students] get to do. I continue to learn my craft all the time. Don't get me wrong," she continued, "I love learning for learning's sake, but that's not always institutionally available or practical because I'm so busy. Learning just for the sake of exploding little brain cells up there is something that just doesn't happen as often [as learning art skills in the course of work]."

Buyukas first enrolled at the University of Oregon as an undergraduate in sociology before changing to fine arts at the age of twenty. She earned both her B.F.A. and M.F.A. in metals. "I was taught that jewelry is a fine art," she says, "not a mere craft, not a plebeian activity, and that's how I teach it. After I graduated with my M.F.A.," she says, "of course I wanted fame and glory as an artist. I had made a series of large body sculptures in school and I went to New York and took them to a jewelry store and gallery owner on Fifth Avenue. He liked them. He told me he wanted them to be photographed with models and said he'd do all the homework for me, talking to

the people at *Vogue*, the whole nine yards. This was in summer. Then he told me how many pieces he'd need by December and I realized it was totally beyond my capacities to produce them. The $300,000 worth of equipment and the workshop I'd used to produce the pieces I had made over the course of six years were three thousand miles away, in Eugene, Oregon. Very depressing, the hard facts of life as an artist.

"So I ended up back in Oregon, and I worked for Nordstroms and took other jobs just to survive as an artist. Then I married," said Buyukas, "and had my two children and that was my life for about six years. My husband began as a teacher, then switched into carpentry. When I'd been at home about six years, he was almost killed on the job. They were raising a beam overhead and he and another man happened to walk into an area that wasn't cordoned off like it was supposed to be. [The beam fell on him.] If he had bent over two inches it would have hit him in the head and he would have been killed. He's a safety nut and he was furious, but there was nothing to be done. He went through a long and trying rehabilitation, and that's what threw me out of the cocoon," she said. "It was either go back to school and train to do something or starve.

"That's when I went into the art therapy program. To help support us, I worked cleaning houses from 4:00 or 5:00 in the morning until 7:30, when I'd go home and be with my son for the rest of the day until I picked my daughter up from school. Then I'd go to my school for the rest of the evening, frequently do the shopping at about 11:00 at night, do my homework until maybe 2:00 A.M., crash down for a few hours sleep and do it all again. I did that for almost two-and-a-half years, and it was very stressful, but I also learned a lot in that period about art and the human psyche. I learned a lot about the relationship of teaching and the responsibility of the individual. What I learned most profoundly is that human empowerment comes from process. If you can teach somebody a process and they can master that process, the sense of accomplishment far exceeds the physical act or what can be described about it physically or emotionally."

teaching philosophy

Knowing Process and Process as Knowing

She went on, "I find that students who are taught basic drawing skills, basic art skills, no matter how rote they may seem to others, can step out from that and learn all the content in the world. You can introduce them to history, to the depth and breadth of content in art, but if they're struggling and feeling negative about the use of the right sides of their brains, they'll close off those other potentials, too. And when they're frustrated that they can't draw like

Dürer, I ask them who they think they're comparing themselves to and do they realize that he started at age four? And that he started with rote activities? You know," she said with some emotion, "if we started our children younger, like the Japanese do, I don't care even if they have physical disabilities, there would be a much higher level of accomplishment in art. Right now I have very able students who stopped growing in a visually expressive modality at about age six. It's very difficult to reach them, and get them to reach out. They simply don't have the tools. And with my adult students from Mount Hood Community College, it's even worse.

"So I start with something nonthreatening in my classes," she said, "something highly structured, something like line play, or paper cutouts, or even copying if it gets down to that, because once you get the skill registered, once they've made the connection between, let's say the metal and the design, it's amazing how people will free themselves up! It may take three weeks, it may take three months, it may take six months, but all of a sudden this student who was showing no sense of creativity or imagination is imagining possibilities and playing with them in a medium in rather creative and skillful ways. I'm not sure you can get there without first having gone through the rote learning."

The first highly structured project in Buyukas' Jewelry One class is a metal wire pin. "They need that in the beginning," said Buyukas, "to get good work.

"Most of my jewelry students have no art background," she continued, "and open-ended, creative projects are threatening in the beginning. So in the first wire pin project I begin with basic design: repetition, contrast, balance, refinement, and so on. I get them to loosen up through nonthreatening play and see lines, for example, not as threatening, not as drawing, but as just another tool, they can use to communicate visually. A few students copy designs at this first stage, not believing in their own design ability, but most develop their own designs. And the second pin they make must be an original design."

Back in the jewelry room, those who are done with the pin have turned it in attached to a completed self-assessment sheet. The finished pins are displayed on a black velvet board at the front of the room. In the back of the room Buyukas is explaining to a student who is behind the rest, and obviously intent on debate, why he needs to do the first project just as she prescribes it. She tells him that he needs solid skills to be creative.

He doesn't accept that, saying "But a wire heart?!" and moves away in an insolent teenage pout. She ignores it and moves around the room, reinforcing the criteria, standards, and rubrics that will result in a successful completion of the piece in progress.

"What did you just finish doing here?" she asks one student.
"Polishing," he says.
"Right!" says she, "and next?" He's vaguely confused. "You're going to scrub it like the dickens," she says, "then we drop it in there." She's points to the sonic cleaner. She directs another student to cut her wire at more of an angle, then turns and says to a third, "Let's see. It's showing file marks still, right here. Use the 200 [grit] sandpaper, like this."

As she moves to the drill press with one student she asks another, "Did you get that filed so the surfaces join right?" And to another, "Your flux is moving away. That means your torch is too hot." Yet another asks about making a bend in the wire. She asks in response, "Do you want the curl to come down in front or behind [the clasp]?" The student tells her behind. "Then we'll have to take these pliers like this and . . ." She demonstrates what is to be done. According to Buyukas, "Creative expression will be malnourished and stunted without the skills to carry it."

The next period, in the graphic arts class, it's the same attention to the skills development that she feels must precede and carry creative expression. Students are working on portfolio covers "that sell themselves and their skills." On three large sheets, taped to the board like tablets from God, she has written out the portfolio cover criteria:

The object is recognizable but
morphed, exaggerated, distorted/skewed, and/or out of context
The eye is mapped around the illustration by
color, line, texture, space, form value, and/or shape,
and by repetition, unity, contrast, and/or interest
The picture shows
unity (everything works together:
contrast/variety, dark-light, thin-fat, etc.)
emphasis (what stands out)
good positive and negative space relationships
balance, rhythm, proportion (skewed, exaggerated, morphed)
The image is
clean, neat, well drawn,
has thoughtful placement of words to image,
high contrast, states an idea, sells you as an artist

Buyukas' comments to the graphic arts class are mostly directed toward visual problem solving: "Where's your light coming from?" she asks a student. "Intense light like this eats color," she continues. "Think about using some of those French grays here. To another student she says, "Look at this

lemon. I mean really. Look. See the red undertones here, the gray-green undertones here at the bottom? It's not just yellow."

One kid says to me, "Ms. B shows you how to do stuff before she'll let you go off on your own."

Almost as if she overheard him, from the front of the room , she says, "Remember, do not experiment on the final piece. Come up with a palette. Experiment on your practice sheet. Then do it on the finished piece."

When there's a little break in the action she says to me, "I would love to do more analysis and research with these students and some years I have been able to do that because the majority of my students have been college bound. I'd love to do journals and self-directed learning in here, like they do at [a rival high school], but the realities of this situation just don't allow it. It's due to a combination of technology, population, and politics. For example, we're seeing a sea of nonreaders and low-level readers coming through the system now, and four or five of these kids are ESL [students who speak English as their second language]. If I don't do hands-on art the kids will take a different elective and I'll be out of a job."

With half the period gone, these graphic arts students are finally settled in. The ambient quality is calm and self-directed, with another forty minutes to go. The eighty-minute periods are the result of block scheduling. Buyukas teaches half of her classes one day and the other half the next, so she sees each class, including this graphic arts class, every other school day.

The graphic arts room, down the hall and up the stairs from the jewelry room, is shared by three faculty members. There's an absolute plethora of stuff on the wall. There's stuff in every nook and cranny. Tables and stools are pushed hard up against each other and kids are knee to knee. The place feels like it's bursting at the seams. There are about twenty students packed into this classroom that seems too small to hold them.

Buyukas told me, "I have a standard of cleanliness and orderliness, and there may be a room or two around here that has everything in place. But it's not this room where three of us share the cubbyholes. Look how I have to tape these criteria for the portfolio cover over other work!"

At the end of the period she takes it down again and takes it with her. Every time there's a new assignment she writes out new guidelines on new easel sheets, sticks them up and takes them down again. So when the bell rings, it's back down the stairs and down the hall to the jewelry room with a box full of stuff to put away before the next period starts. The following period, another art teacher who shares the jewelry room comes in to prepare for her class, cutting paper on the paper cutter while Buyukas teaches her class.

The Crunch of Success

Ironically, this space crunch is a by-product of success. The number of rooms has stayed the same while the number of faculty and students served has grown dramatically. The six art teachers share either four or five rooms depending on how it's defined and who's doing the defining.

According to Ron Linn, "About fifteen years ago, when the number of students was shrinking, the district liquidated some buildings and brought the central office into the vocational and fine arts building. So half the building is the district office. Now we're growing again and crunched for room."

Besides space, the other problem that has come with success in the David Douglas Art Department is a funding shortfall for expendable supplies. As Ron Linn puts it, "I wouldn't say our budget is shrinking. Rather it's stayed the same while the department has grown. But in a sense it's shrinking because the number of students we service keeps increasing. That's a district problem. It's not that they're not supporting us. It's just that they don't have money to do that. We get about $750 per teacher now, for supplies, but we also charge lab fees in most of our classes to help supplement those supplies. For example, the ceramics program has eight sections with about twenty-three students in each section, and we go through probably eight tons of clay a year. That eats up my budget in the first quarter, so the lab fees we get from the students get us through. And if a student can't afford it we just smile and nod and say OK."

What Linn told me about lab fees was confirmed by Buyukas in the fifth-period jewelry class. She told the class, "Some of you are leaving for the college fair. Listen before you go. Pins and drawings were due last week, so we're not going to spend any more class time on it, but you have to be responsible for finishing it, so come in when you can. I'll give completed and graded pins back when you pay your lab fee. If you can't pay, talk to Ms. Richards, then come talk to me privately."

In spite of the cramped quarters and a proportionately shrinking budget, there's a real collegiality among the art faculty and a sense that the jobs they have are special. As Ron Linn put it, "One thing that's special here is how well the staff works together. They care about each other and each other's subject and support each other. That's unique. And they're dedicated: I mean all of them, from the first-year teacher to our teacher who's about to retire. I'm continually impressed, as close as he is [to retirement], that something new is always happening in his classroom. He could just pull out old lesson plans from now until forever, but he doesn't. Nor does Gayla Buyukas, nor do any of them."

Buyukas says, "I feel quite blessed to be working at David Douglas. It was a lucky, lucky thing actually, getting this job. I was in Emily Young's art education class [at Portland State University], and there happened to be a young teacher in my class who was pregnant. She and I liked each other's ideas, and she called me and said, 'I'm pregnant. I'll be staying at home on a long-term maternity leave. Would you like to do a long-term sub?' I just had this overpowering feeling that she would not be back," said Buyukas. "So I've been here since '94, and I feel quite blessed."

The Heart of the Matter

"Well, what makes your job so special?" I asked her.

"I teach art because it's personal," she responded. "When my students are actively involved in learning, I get an incredible rush. They are the reason I do it. When I fail to reach them I dream about it. The students in some ways become my kids. It's true that there's a certain repetitiveness in the ritual of being a teenager from a teacher's perspective, and some of my friends, if they won the lottery, would quit teaching. But I have a hunger in me to experience my students' art in a very fundamental way. I get fundamental enrichment in being tied to the process of their growth, of being a necessary part of humanity, of having that tie to the next generations."

"And what's your biggest frustration?" I asked.

"My biggest frustration," said Buyukas, "is that there are a million pies here to juggle, each with a million cherries, and if you try to move one pie there are cherries all over. Like I'm supposed to run a CAM business out of graphic arts, and I don't want to whine because we all do it, but it's difficult to balance all the demands [imposed by the state] and not have that clash with attending to actual needs of my students."

According to Buyukas, those needs center on their human growth, and that growth is facilitated in art through the act of intelligently making aesthetic objects. She believes that the stereotypical "slam" of referring to art as Basket Weaving 101—as an activity done by stupid people—just shows how ignorant critics are of the complex intellectual and emotional synthesis required to meaningfully connect the hand and the eye and the brain and the heart.

"There is no such thing as stupid art," she says. "I took a basket-weaving class with a group of adults last year and we learned how to do basic wet weaving using cane. It didn't take us long to realize that even at its simplest level, basket weaving takes a tremendous amount of skill and intelligence. It takes a skilled artist to make it look easy. I believe with Gardner that art is at the top of Bloom's taxonomy in terms of intellectual and creative synthesis.

Would you want a surgeon working on you who was not good with his hands? with tools? with relationships of form?

"Not coincidentally," she continued, "I read that a third of all doctors are artists. The arts are a critical part of our humanity. They are what tie us [together]. They're the collective primeval dance. And now in the face of technology, human isolation, and bureaucracy, the humanizing function of the arts is even more important. So it's really ironic that [state mandates] go out of the way to cut the arts out of the curriculum as if they're peripheral fluff. In some rural areas of the state they've not only cut art but band, too. Luckily my own school is bucking this trend. I think it's absolutely critical to have the arts, and obviously my school district does too. They don't have to have six art teachers. They could get rid of some of us. At Cleveland High School, for example, they have forty-five kids in a ceramics class with one art teacher and eight wheels. So I feel quite blessed."

They must be doing something right in the David Douglas High School Art Department because they have additional classes, faculty, and kids and are increasingly significant in the larger scheme of things at school. Their good work and good fortune in the larger political context, then, may go a long way in explaining why the art faculty at David Douglas is so positive, seems to be successfully adapting to current realities, and even is growing in the face of some political adversity from on high. The realities of not enough room, shrinking budgets, and particularly, the seeming omnipresence of CIM and CAM and PASS—and whatever next week's state or national agenda may be—seem manageable in light of a supportive school district that values the arts. The national tendency toward micromanagement of the schools is as strong in Oregon as anywhere, but the blizzard of bureaucratic paperwork hasn't buried Gayla Buyukas and her colleagues at David Douglas High School. At least not yet.

Profile: Gayla Buyukas

Current Position: Jewelry and graphic design teacher, David Douglas High School, Portland, Oregon.

Education: K–12, Sacramento, California, public schools; bachelor of fine arts degree, University of Oregon, 1974; master of fine arts degree, University of Oregon, 1976. Approximately forty-five additional graduate credits in art education at Portland State University and another forty-five in art therapy from Marylhurst College.

Practicing Artist: Jeweler/metal smith/designer since 1971, watercolorist, ceramic and metal sculptor, graphic artist and illustrator.

Teaching Experience. She's in her fourth year of full-time public school art teaching, all at David Douglas High School. She describes herself as an "old new teacher." She had nine years of volunteer service at her children's schools as they were growing up, and several years of substitute teaching, in and around Portland, as well as seven years experience working at the Children's Museum in Portland as a receptionist and advocate.

Current Teaching Load: Six classes: Jewelry One, Jewelry Two, and Graphic Arts One.

Extra Professional Duties and Activities: CIM interviews with students at David Douglas High School, exhibiting artist, member of the National Art Education Association, the Oregon Art Education Association, and the National Education Association. She judged portfolios for the National Art Standards Board in San Francisco in 1996, and worked on the original draft to describe proficiency in the arts for PASS in 1995 and 1996. Buyukas was selected as the Oregon Secondary Art Educator of the Year for 1999.

Supplies and Expendables Budget: $750 from the school district and a $15 lab fee from each student in jewelry, "which comes to approximately $1,500 if everyone pays, which they don't. Jewelry is expensive to run so these lab fees make it possible to do it, but without a dime left over."

Salary: $37,600. "I'm not complaining about it. I can't compare myself to a business person but this is the most money I've ever made in my life. I have good benefits. My salary will go up but I started older so I won't be retiring when other people do. But I have a good salary and I'm happy about it."

7
Donald Sheppard

Shepherd to the Community

The Last Week of School

It's the end of the school year and the kids at Griffin Middle School, like the kids everywhere else in town, are bouncing off the walls. The teachers are counting the days, just trying to hold on. Donald Sheppard, the art teacher, is no different.

"Kevin!"

It's about twenty minutes into Period D, and Kevin has been walking around the room with a weaving on his head, flirting with a girl who's physically mature by poking her in various places, which makes her laugh like a younger child.

"Kevin," says Mr. Sheppard with quiet authority, "Give me that weaving and go sit down."

"I don't have to," says Kevin.

"Yes, you do," says Mr. Sheppard.

Kevin looks up and sees that Mr. Sheppard means business and goes to his seat. Sheppard is at his desk. There's a line of five or six students waiting for his attention. A girl named Tina cuts in front of a boy who came into class late, claiming that he couldn't get there on time because of his crutches. Tina and the boy flirt with and shove each other a bit and it spreads to the rest of the line until Mr. Sheppard calmly says, "OK, Tina, take that spot." She does.

Sheppard looks over to see that Kevin and a couple of others still don't have their weaving projects out. He looks through his file cabinet. "Here you go, Kevin. This one's yours."

"'Bout time," says Kevin.

Mr. Sheppard gives him a look.

"Thank you," says Kevin.

"Get rid of your gum," says Mr. Sheppard.

"What gum?" says Kevin.

Sheppard is already focused elsewhere so he doesn't seem to see Kevin opening his mouth in a huge grimace, gum under his tongue, to prove that he has none. I found out later, however, that Sheppard did see it and, in fact, that act was the straw that broke the camel's back. That night Kevin's parents found out all about what he had done at school during the day.

The yarn for the weaving projects is kept in plastic milk jugs with holes cut in the top, designed so it feeds out the spout, but two kids have taken the yarn out of one of the jugs and are tossing it back and forth. Mr. Sheppard clears his throat as he looks at them. They stop. As they return to their seats one says to the other, "You turd!" They both laugh.

Outside in the hall, all of a sudden, it sounds like a stampede. Ms. Wade bursts out of her door, just across from Mr. Sheppard's and shouts at the stampeders in a big voice, "Hey stop, now! Where are you boys supposed to be?!"

The disruption is almost totally unnoticed in the art room, where most of the seventh- and eighth-grade students are now on task. Of course there is the considerable tapping on desks with fingers and pencils or on the floor with heels or toes. They're middle school kids. They simply can't help wiggling and tapping and hopping up and sitting back down, and whispering, and making rude sounds to impress their friends.

It's not that Mr. Sheppard has a control problem. He doesn't. In fact, it was a particularly bad day for all the teachers, even for the end of the year, because it was an awards ceremony day. The ceremony for the sixth-grade Leopard team had taken place earlier in the day during an extended homeroom period and the rest of the periods had been shortened.

At the beginning of the homeroom period, Mr. Sheppard says, "OK, you all know that in about fifteen minutes we're going to the awards ceremony." That's all he gets out before the kids go ballistic. When he finally gets their attention again he says, "Let me be proud of you today. If we're going to get to the assembly on time I'm going to need you to cooperate."

At this point one kid pulls up a pants leg—it's a sign of defiance—and puts it back down when Mr. Sheppard gives him the look. Everyone is absolutely wired. "Right now," Sheppard continues above the din, "I am not proud of you. It's way too loud in here."

The announcements come on the intercom. The kids get relatively quieter but a number of them converse right through them. From somewhere in the distance the intercom voice is saying, "The FCAT scores are back and will be given to you during your language arts period today. . . ."

After the announcements, Mr. Sheppard says again, "I'm not very proud of you right now. You were talking through the announcements and you won't be informed and I won't either. Now listen, here's the plan. We will get in line to go to the awards ceremony when we have put away all the free drawing materials and when we are quiet. After we get in line we will not be leaving unless we continue to be quiet. You need to take your book bags."

There's lots of wiggling and tapping and talking.

"Do you want good seats in the awards ceremony?" Sheppard asks them. "I hear a class leaving for the ceremony now. There go the best seats. Do you want the second-best seats? When we're quiet, we'll be leaving." There's still the wiggling and tapping, but now they've quit talking and he has everyone's attention. He knows that on this day that's as good as it's going to get, so he lets them line up. They're relatively quiet in line so he lets them go.

"Wait for me at the stairs," he says.

As we move to catch up with them, I ask, "Are these sixth graders?"

He gives me a significant look, like Can't you tell? and says, "Yeah. Sixth graders."

Besides this sixth-grade Leopard team there are four others in the school: the other sixth-grade team, the Cheetahs, the seventh-grade Bengals and Lions, and the eighth-grade team. We get to the lunchroom second-to-last for the Leopard team awards assembly and take seats toward the rear of the room, on benches affixed to bright blue Formica-topped lunchroom tables facing a raised stage at the end of the room. But the microphone and podium are not on the stage. They're on the floor level in front of the stage. There's a woman trying to get everyone's attention. The microphone won't work.

It's going to be a long day, I think to myself.

The Spirit Moves Him

In this end-of-the-year mayhem, Mr. Sheppard is mild-mannered and seemingly unflappable. Dressed in a polo-style knit shirt, khakis, and loafers, and seeming to have more wisdom than his thirty-six years, he ignores that which he should—the minor stuff—and that which he can't do anything about, deals with that which he needs to, and has the wisdom to know the difference. Later he told me, "When you don't have control, it can be a nightmare. When you don't have control, you don't have anything."

The control he has comes largely from the fact that he really cares about the kids, and they know it and respect him for it. He not only works with kids at school but also through the neighborhood church in the Griffin school district where his family goes.

Maybe the only thing more important than school and church to Donald Sheppard is his family. In fact, when I first called him to see if he'd participate in this study he answered the phone in a soft, hoarse voice.

"Hi, Donald," I said. "Do you have a cold?"

"No," he said. "I'm trying not to wake up my daughter. She's asleep here on my chest."

At school, later, I said to him, "When I called you last Sunday night to make final arrangements for my visit, you weren't home till pretty late. I suspect you were at church."

"Yeah."

"You've talked to me about working with kids at the church. It sounds to me like that's a pretty important part of what you do and who you are."

"Yeah. Very much so. I'm very glad you asked that because I spend a lot of time at the church. It's something that's very, very much a part of my life. I say that too because my wife reminds me of the time I spend at church," he said laughing. "I'm pretty involved. I'm an organist."

"Really! Did you take piano lessons and all?"

"Not at all. My father plays the piano some and he reads music a little bit and he taught me briefly. But I don't read music. I know what a C looks like and I know what a staff is."

"So you play organ for the church without reading music. That's pretty amazing," I said.

"I play by ear. That's the term that's used. My wife reads music, and sometimes when we're doing a song at vacation Bible school or whatever, I'll have no idea what it's supposed to sound like, so I have my wife come read it. She can pick it out." [He hums a bit.] "Oh, that's what it's supposed to sound like! Then I can play it."

"So you're the organist for your church, and you said you do vacation Bible school?"

"Right. The art part of vacation Bible school. And I might do the music. That depends on what the need is that year. Because I play the organ I'm also involved with two choirs. The bigger choir, [which is] the older choir, and the children's choir, what we call the youth choir. So I make those rehearsals every week."

"So how many days or nights a week do you reckon you spend at the church?"

"Well, there are some other things I do at the church, too. I'm also an ordained minister, and I help my father in that way."

"So your father is your pastor?"

"Yes. I was ordained in '89, one year before I got married."

"So do you conduct services?"

"Yeah, that's what I'm getting at."

"What do you do in your spare time?" I asked.

He laughed. "Yeah. So I assist my father there in the church. I'm his first administrative assistant. He's there on two Sundays out of the month and he's also there on Friday nights to do an evening service, and other times I'm there. Now I don't do the ministering all the time he's not there because we have about ten other ministers. Two of them are ordained. So ultimately Dad calls the shots but I have a lot of responsibility."*

"So for example, what were you doing Sunday night?" I asked.

"Well, our services end about 9:00. We had Sunday school from 10:00 until 11:30, and services go from about 11:30 till about 1:00, and then there's the evening service. The church is on the corner of Brevard and Dewey, right here in the neighborhood. The new sanctuary seats about 600. And when my father is there and when school is in session, it's full."

"So do you have any of the kids from church in your class?"

"I sure do," said Sheppard.

"So you get two shots at them."

"I sure do, and boy I love it. I know their parents, and oh, man, those are the kids I don't have a bit of problem with. Direct access to parents is the best. Sometimes a kid will tell me that he saw me at church, and if I don't know his parents I'll tell him, 'Next time come up and say something to me and let me meet your mom.' That's when their senses kick in and they start to back away," he said, laughing.

"And we tape a service for television on Tuesday nights, at 8:00," he continued. "Sometimes I'm leading the song or something and frequently

*Since this interview was conducted, Donald Sheppard's father died. Donald is now the minister and leader of the church.

the kids here at Griffin come up to me and say, 'Mr. Sheppard! I saw you last night!' So the kids know. But sometimes it's also amazing what the kids don't know. And even this late in the year some of them are just finding out. 'Mr. Sheppard, do you sing?' "

Griffin Middle School: A Mixed Bag

"Who are your kids?" I asked.

"I teach grades 6 through 8," he said. "There are close to 800 kids in the school. The school is pretty well balanced between white and black."

"From my tally of your classes it's about 55 percent white, 40 percent black, and 5 percent Asian."

"I think that's just about right," he said. "This school reaches out way past its neighborhood community. It sits almost in the heart of the city. Very close here are three project areas, the McComb Street Project, the Basin Street Project, and the Joe Louis Project, but the school district reaches all the way out to Lake Jackson. So a lot of the white kids come from that area in the northwest part of town. As a matter of fact, where I live in Settler's Creek, the kids go to this school. It's interesting because some parents let their kids get up to this point, and don't like the location and put their kids in private schools. One little girl's parents in my neighborhood came and looked at the school but they couldn't get over the location."

"Meaning that it's in a black neighborhood?"

"Maybe. It is in the inner city. The front of the school is on Alabama Street. The very name Alabama Street is enough to deter some folks. The other side of the school is on Old Bainbridge Road, which goes out to become a scenic canopy road, but Alabama Street goes through the Joe Louis Project. Not all the kids from the McComb Street Project come to this school. I think some of them go to Raa Middle School. So we have a mix of whites mainly coming from the northern end and blacks mainly from this area, but there are some black kids from the northwest area also."

"I didn't see any racial tension in your classroom. Black kids and white kids were sitting at the same tables, talking with each other. Do they have assigned seats in here?"

"Yes, they have assigned seats. That is on purpose. I take race into consideration. Also boys and girls. I try to mix them up too. If I have knowledge that someone is a big talker, or someone is disruptive, then I will seat that person next to someone who is probably not their own race or their buddy. You might remember Tina, for example. I talked to Tina several times."

"I remember," I said, thinking of the pretty, flirty, African American girl.

"I put her next to Lindsay, who last year had the art award for the high-

est average. At the next table behind Tina is another white girl. And I've also kept her away from boys, because she's at that age. But she still hollers over to the black fellow two tables down, so it's not perfect.

"But as far as racial tension," he continued, "I guess you kind of have to be here for a while to see it, because I've definitely seen it. I'll go ahead and say this. To my surprise there was a kid this year who accused me to his parents of being more lenient to the blacks than to the whites. That was a big surprise because I think my stance is just the opposite."

"Yeah, that's what it seemed like to me," I said, agreeing with him.

"But I've had the opposite said about me," he continued. "I've had the blacks say, 'Hey, you were over there with that white girl.' But as a matter of fact that was one of the things I learned from the other teachers, one of the first ground rules is no racial slurs. You know, we just don't do that. It's there in the rules I put up in the classroom. But it's [racial tension] there. It is there. And there is one class in which it is there more. That's D period. That's the one that has the most discipline problems, too. You remember Kevin?"

"Oh, yeah."

"I sent a note home to his parents, and I don't know what they did but they did it well, because he was an angel today."

"How about the puberty aspect of teaching this age student?" I asked.

"Well their hormones are really raging," said Sheppard. "And it is surprising to me sometimes what these kids are aware of, what they know. I ask myself what did I know in sixth grade. I didn't know half of what they know. The notes that I pick up are way too mature. They use words that you normally wouldn't want to put into a conversation, and they're talking about sleeping with a guy. Or a girl might be writing to a guy asking if he wants to sleep with her. This can be as young as sixth grade. They're, I want to say, too aware of their sexuality, that's for sure. They're very preoccupied with it. You know, at some point it's normal, it's normal, but it seems to me from my own experience, it's more and it's younger these days than when I came along. I don't know if that's from the culture we're living in or from what they see on TV and in the movies. I'm surprised they're able to see those kinds of movies, because they're definitely not rated for them."

"Do you have any special students in your classes, emotionally or intellectually challenged kids, or other special conditions?" I asked.

"Oh, yeah. Yeah, that's a main characteristic of a lot of the classes. Definitely. The ESE [exceptional student education] kids get brought into here: the kids with the learning disabilities and the gifted kids, too. I had one kid all year last year who was ADD [attention deficit disorder] with hyperactivity. It basically took me all year to find out what buttons to push, because

you know kids just have no mercy and they would get at him for acting out or being disruptive, and that's the last thing they should do because that just spurs him on to greater disruptions. That made him a lot worse. But finally I found out with him that I could actually write a note to his parents, and he actually would take it home. I had a smiley face note and one with a frowning face that would say Keith was not so good today, and a space for comments. And that did it! I mean, this kid would actually take the note home. For some reason. I mean we can't get people to take report cards home. But this kid would take a note home. But different things work for different kids. I have one girl, now, who has a touch of cerebral palsy, so her motor skills are not so good, but academically she blows them away on the tests."

Teaching for the Social Good

"What's the most important thing you teach, Donald?" I asked.

"Oh boy!" he replied. "I don't want to say that it's not necessarily the art concepts," he said, "but I might say that. I don't want to say that because I spend a lot of time correcting people's thoughts about art not being useful in the world. I spend a lot of time telling kids that they'll definitely use art in their lives, wherever they are, whatever they do. But," he paused, "but, there are so many things that are embedded in just being in the classroom and being able to get along with each other. I mean, this maybe is the classroom that utilizes cooperative learning more than the others. Every day they have to learn how to share materials at their table, for example, and they have to learn that they've been put into a situation where they have to learn to cooperate, because I assign seats. That's one of the first things I do."

"So they have to socialize with each other."

"Right. They have to find a way to get along with that other person enough to get what they need to, done. And that's what's going to happen in their lives. They're going to move to a place, well, where they're always going to have assigned seats. There's no guarantee that you're necessarily going to move next to someone you like or someone who's your buddy, but you're going to have to find a way to get along with that person, so both of you successfully get done what you need to get done. They learn that in here, I hope. They learn the discipline of respect for one another.

"And they learn time management and things like that," he continued. "When we're ready to go on to the next thing, I might hear, 'Oh, but I didn't get done!' Well, I try to make sure there's enough time and still give the kids who are going too fast something to do. You have to keep everybody busy, that's for sure. And they need to learn to manage their time too. You might

have the best of ideas, and you may be as brilliant as they come, still you have to accomplish the task and prove yourself within the limitations presented."

"So life lessons are more important to you than art lessons?"

"Yeah. That's what they're learning. They're learning life lessons."

"So what kind of long-term goals do you have for your students?" I asked.

"Well," he said, "in addition to what I just told you, I want them to gather a greater appreciation for art. I don't necessarily want them to have memorized facts and skills. I don't want them to leave with a bag full of facts. I want them to leave with some tools that will help them continue to explore things when they get out. Like I want them to be able to go somewhere and see some artwork and know how to read into it a bit. I want them to be interested in and use art in their lives. I want them to use art to enhance their lives."

"What skills and concepts do you think are the most important?"

"I think being able to look at something and see the beauty in it, and being able to reevaluate it, and climb out of yourself and see what someone else's beauty is, then you've grown. It's not necessarily that you have to be able to draw. It's that you have to be able to see. And that's going to change your outlook in life."

Roots, Reckonings, and the Road to Teaching

"Speaking of which, can you tell me a little about how you got to this place in your life?" I asked.

"Well," he said, "I was born in Gadsden County, in Quincy, Florida, May 20, 1962. I lived inside of the city limits in Quincy, but it wasn't like living in an inner city. There are maybe 5,000 people in Quincy, which is the county seat, and maybe 35,000 in the whole county. Everybody knows everybody.

"My mother pushed my talent, my art ability. No one in my family had even thought of or considered a career as an artist until I came along. I'm one of five children. I have a twin brother, Ronald, and we're totally different. He's an engineer now. Mom was a housewife. She was a very incredible woman, a very incredible woman. She raised all five of us and all five of us have different personalities, and different interests, and she was behind each and every one of us. Actually both Father and Mother were behind each and every one of us in our separate interests, 100 percent."

He went on, "My father pastored three churches when I was small and everybody in the town knew my father. I was in church quite a bit. He was not only a pastor in Quincy but also a guidance counselor in the school system, at James A. Shanks High School, so he was a busy man. As a matter of

fact he's one of the persons I look up to, and when I think I'm doing too much and I'm going to go crazy, I look at his schedule and say, 'Wait a minute. I don't do half of what he does.' So he was well known, and all any teacher had to say to me was, 'I know you. Sheppard, Sheppard . . . Oh, Reverend Sheppard's son, OK. I'm going to call your daddy.' "

"So you had to be a good kid, I guess," I said.

"Yeah! Yeah! That would keep us in line."

"Did you take art?" I asked.

"When they took art out of the schools in junior high school in Gadsden County, it was really devastating to me," he said. "It was between seventh and eight grade. I was looking forward to being under a particular teacher. I'd seen some work that his students had done. It got right up to the time and that summer they decided to take art out of the schools. But somehow they got a teacher, not an art teacher, and gathered up enough students who had an interest in art so they gave one class. I got into that. But one thing my mother did was get me into some of Tom Harris' art classes at night. He taught some courses that met once a week. And in those courses I learned so much. It really stuck with me; sometimes I even think of it now in the middle school setting. I'll be doing something and think, 'Are they really capable of getting this?' And I think back to my junior high times and say, 'Yes, for sure. They are very capable. And someday they will use what they learned.' So that was a pretty significant turning point in my life, where I learned so much in just those little classes."

"Did you have elementary art?" I asked.

"Yes. The first two years I went to Stephens Elementary. Now it's no more. That was before integration. Third grade is when we integrated. We switched to George W. Munroe."

"I understand that's when the white kids went to the academies," I said.

"Well, it took a little while, but that was a significant milestone for me, too. Really, at the time integration," he paused, searching for what he wanted to say, then changing direction he said, "For example, the high school today—Shanks High School—is predominantly black, but in the beginning of integration it was predominantly white. Over the years the whites moved out to the private areas. But that was a significant time because as I look back on it today I can see some things as far as how they impacted me. For example, I remember at one point being in the tub, and saying to myself, 'Hmm, I wonder how much of this can come off?' I remember bathing myself in one area and I thought for sure I was getting much lighter. Those type of things are very real. When you think about them, it makes you mad."

"That makes me want to cry," I said.

"And then I was very sincere about it," he continued. "And now when I think back on it, it makes me want to cry, too, that I really had that mentality at one time. I certainly did. There were some things that I go back and remember even now that I'm totally shocked, totally surprised by. I remember I must have been about in the second grade, and I had a tooth that had to be pulled. So I had to go to the dentist. We were walking up to the dentist's door from the parking lot, and instead of us going to the front door my mother took me around back. I remember asking Mom, 'Why are we going in the back door?' And she was like, 'Aw, just come on, Donald, and don't worry about it.' 'But the front door is just around there,' I said to her. 'Come on, Donald!' she said. At that point she didn't explain, so it really left me with a question mark. And years later, I was thinking back on it and said to myself, 'Oh, is that what was going on,' thinking about civil rights and Jim Crow laws."

He continued, "So that was a significant time. I remember telling my big brother when I was about eight, I was very proud and I came home and said, 'I have a white girlfriend!' My brother, who is eight years older than I am, said, 'Don't you ever say that out loud to anybody! You know because they will call you an Uncle Tom.' So all of that was significant."

"So when integration came the white kids didn't flee immediately, then. It happened over time?" I asked.

"It took a little time," he said. "I would say several years. The rest of my elementary school days, up through sixth grade, it was predominantly white. When I got into Quincy Junior High, then white students started thinning out. My father went from being a guidance counselor at the all-black high school to Shanks, so we were all changing over."

I asked Sheppard, "Did you have a high school art teacher?"

"Yes. At Shanks. His name was Mr. Hudson. I still see him sometimes. A real laid-back man, very, very, very nice. I remember there were some of us who were very interested in what we were doing in art and we kind of got together. We were the ones at the table that were really working, you know? I think about it today and think about troublemakers in my own classes, and I think about the kids who want to work and know what they're thinking. But Mr. Hudson was a very good force in pushing the art theory also. Or if you brought something from home that you were interested in, he'd say 'OK, well, why don't you work on that?' And he'd give us some input on it. So I'm really grateful to him. And of course, he was instrumental in my getting into college [giving me] references and so on."

"Did you go straight to college after high school?"

"I went to the Columbus College of Art and Design, in Columbus, Ohio," he responded. "I was very excited about it. It was like one of the top

three independent art colleges, so I was really kind of stuck on it. So I applied and got a $1,800 scholarship, and that was it. I was going. But it was a bit of a culture shock. Shanks, like I said, had turned predominantly black at that time. I was number three in the high school. And it was kind of known about me that I was the artist in the school. If you needed any art done I was the one. But I got to the Columbus College of Art and Design and *everybody* could draw. *Everybody* had incredible abilities. It was a humbling experience. And Columbus College of Art and Design is also predominantly white. Out of a thousand students there may have been about thirty blacks. As a matter of fact I was the only black in my major."

"What was your major?"

"Industrial design," he said. "I think maybe the reason I went that way is that in high school so many teachers said 'Wow, you're so good in physics and math and you're going to waste this on art?!' I think I wanted to remain a little in the technical area just to prove a point. And I do enjoy industrial design. I did follow it through, but it's different than sitting down and enjoying a day out painting, you know? Because you're catering to someone else, making someone else comfortable, you're designing around somebody, unlike painting or drawing where you're taking care of your own needs, taking care of yourself. There are no rules. You're not worried whether this is going to fit somebody's else's needs."

"Did you go straight through college?" I asked.

"Yup. I went straight through, in four years and a summer. I received a B.F.A. in industrial design with a minor in advertising. It was a very good school. Living in Columbus, though, was sort of a shock. One of the reasons I was so raring to get back here was that I had enough of the snow. But when I looked outside that first time and saw it I woke everyone up to see it. I was so shocked, so in awe, to see everything white like there was this Christmas card out there, and it's real! That was beautiful. But by the end of four years I had learned that it doesn't stay white always, that it gets muddy and slushy and there are blizzards and it's gray. We had a blizzard once and I had no idea about it. I was into my studies and wasn't listening to the news, so I walked up to the school to do some work and everything was closed. Anyway, those kinds of things drove me back this way.

"So I came back, in 1984, to Tallahassee. To my surprise it wasn't as easy as I thought to get a job as an industrial designer. At some point I had to accept that, 'Oh I probably won't get a chance to work here in Tallahassee.' I put in applications in bigger cities and got used to getting rejection letters, so at some point I just felt like I needed to work at whatever. I was tired of living with my sister and brother and living off Dad's money. I was sup-

posed to be grown. So I started seeking jobs just to be working. I did some freelance work as a sign painter. Then there was a couple who were running a record shop and liked me and hired me and I worked at that record shop for about a year until I was hired at *Homes and Land* Publishing in '86 as a paste-up artist.

"And that was good for me because I was finally hearing those art terms that I was used to and I was using border tape again and X-acto knives. 'Hey, so good to see you, X-acto knife!' And all those materials that I was used to using. I worked for *Homes and Land* for nine years: '86 through '95. The company really prided itself on innovation and being at the cutting edge of technology. I was glad to be there for that. All paste-up went to computers early on, for example. As a matter of fact, I teach the kids how to do that now. We go into the computer lab and we do layouts and that type of thing. So that part of the company I was really happy with. But there was some lack in what I'll call the humanness of the company. You just felt like a number."

"Is that part of why you decided to become an art teacher?" I asked.

"Well, I kind of felt like my time was up there," he said, "like I had gained everything I needed to there, and still keep my sanity. But it wasn't just that I was running away from a job. I knew I worked well in the church with young people. I had a little class there for middle school students from age thirteen to seventeen. I would teach them in Bible study class, and I really enjoyed it, 'cause you know these kids are very honest and straight up and if you need a haircut they'll tell you. If your clothes didn't match they will tell you. You have to be transparent or you won't make it. So I really enjoyed being able to touch kids' lives.

"So somewhere around when I got close to thirty, it really hit me. 'Wait a minute,' I said to myself. 'Are you really doing what you want to be doing?' I mentioned it to my wife—we got married in November of '88—and she's a very good supporter. She's quiet, a deep thinker, she's reasonable, and when I mentioned that I might like to get into the classroom she said, 'Well you might want to try that. Why don't you do that?' So I came into the program in '90, and continued to work for *Homes and Land* full time while I worked on my degree, and graduated with a master's in art education from FSU with certification in April 1995."

"Then I was very fortunate to land this job. This area, having the universities, is kind of saturated with education majors, so I thought I'd be working in Quincy or somewhere else. But I went to the Leon County interview day and there were three schools that needed art teachers. When I interviewed with Griffin, I remember the person who was interviewing me saying, 'You're going to do pretty good today.'"

Teacher Preparation

"So you've been here since then," I said.

"That's right. This is the end of my third year."

"How effective was your teacher training?" I asked.

"My teacher training was very effective, especially since in the program there are those times that you go into the classroom and experience what it's like for yourself. By the time I got back into the classroom—it was a long time for me since I'd left high school—I had to be reeducated about what kids do. I was like, 'Wow, you mean they're really not killing each other in schools like they say on the news? Oh, my goodness, you mean there is some real, real learning going on here?' You have to get in there for yourself. And I think that ingredient of the program was very, very effective."

"Having said that, though, I suspect that you really learn most of what you know about teaching on the job."

"I want to say that's true," said Sheppard. "I don't want to undervalue the theoretical part of it, but it's very meaningful to actually be on the job, and to see other teachers who are experienced, like the lady across the hall, Ms. Wade, who was my Beginning Teacher Program mentor. She was just great, especially in teaching me discipline techniques and that sort of thing. As a matter of fact, if you don't have discipline, you don't have anything. One of the most important things I've learned about that is that you have to begin with things in place, with your rules in place and things all ready to go. Don't leave any stones unturned. You know, I'm a really laid-back person, patient and that type of thing, but early on an experienced teacher told me, 'Oh, you're going to have to be a little bit meaner, especially to begin with. You can always get nicer. You know, there's a saying: Don't smile until Christmas.' I didn't realize the significance of that saying in the beginning. But I did after the first year. So I learned a lot of good techniques from experienced teachers inside the classroom."

"So you have the standard certificate now?" I asked.

"Yeah," he said, "I have the permanent five-year certificate. You start out with the temporary certificate for two years, and get the permanent certificate after you pass the subject-area test and general test. You take those the first year you're teaching. Then you have to have a certain number of points during the five-year period to renew the permanent certificate. You get those from going to authorized workshops or classes. The first year after I finished school, after the Beginning Teacher Program, I didn't want to see any workshops. I was sick of workshops. But last year the DBAE workshop was very, very refreshing. You get to the end of the year and think that you've

thought of everything conceivable—it's all done. Then this workshop has all these fresh ideas and these other teachers that have been through the same thing. And it's amazing. It was almost like I was ready to go back. It was like, 'I can tackle this again.' "

Back in Class and finally in the Groove

On this, one of the last days of the year, after lunch, after the assembly, there's some semblance of normalcy in Sheppard's art room: some kids are lined up at Mr. Sheppard's desk for help, others are at their tables, talking about sports or clothes or boys or girls while they work on weavings. Late in the afternoon two boys are talking basketball while they work:

"I'm getting sick of the Bulls."

"I heard Michael is going to the Knicks."

"He'll go wherever the coach goes, and Pippin's going too."

"Leonard's better than him."

"Are you working or just talking?" asks Sheppard from his desk.

"I'm working and talking," says one of them. Now the basketball talk has spread throughout the room, black kids and white kids all sitting, talking, and working together.

Sheppard goes back to the supply room for more black yarn, puts it in the milk container dispenser and goes back to his desk where the line has stayed formed. Then he thinks twice, stands up and reminds the weavers not to use too much black, white, or blue.

"We're running short of yarn," he says.

Budget and Logistics

After school I asked him, "What would you change to make your job better?"

"Budget," he said.

"Anything else?"

"Budget," he said again, laughing. "Budget. It's like pulling teeth to get supplies. When I came here the first year I had a pretty good supplies budget. I think it was about $600. But," he said with his eyes rolling back, "there were apparently some bookkeeping problems during the past administration, so Mr. Bethea [the principal] really had to get the budget in line, and everybody's budget just went kaput. So last year I went almost the entire year on what I had left from the year before. I got almost no budget. I think I got about $200. This year got a little bit better. I had about $350 or something of that nature."

"How do you make that stretch for a year?" I asked.

"It's very hard. But one thing that was very advantageous this year was that we could have anything copied with no expense charged to our budgets. So I could get worksheets, the paper sculpture patterns. So I can help them understand the difference between shape and form using this one piece of typing paper, cutting it out and constructing it into sculptures. Talking about using the budget wisely, I can copy as many of these patterns as I need for free. So except for the markers and the paint this is a free project."

"I notice that you're pretty careful about passing out and collecting your markers, crayons, and other materials," I said.

"Yes I am," said Sheppard, "because they will definitely disappear. They will definitely go. One of the things that goes the quickest is those Sharpies. But you know sometimes it's not intentional. Sometimes kids will just put a pen in their pocket without thinking about it. I'll have to say, 'There's one more out there. Where is it?' And some kid might have it in his pocket or something, and didn't realize it. But you really have to account for everything and give yourself time to take it up.

"But you know sometimes you can find money in other places," he continued. "I was able to get some new books from curriculum money. There's a new program that's been instituted that says every teacher in the state of Florida has $250 to spend as they see fit. And believe me that's a godsend."

"Do you do candy sales or that kind of thing?"

"Yes, we did that in order to buy the electric potter's wheel. That was pretty successful. But we did the sale one semester and it ran into the next semester so I didn't see those kids, so I had to track them down in someone else's room and so on. That was rough. But we did pretty well. And as a matter of fact that was how I made it through last year. We made over $900 and the wheel cost $600 or something like that, so I used the rest on supplies."

"How many students do you have?" I asked.

"About 120, something like that," he said.

"Your average class size is about twenty?"

"Yeah, something like that. I have two classes this time that are small and one class that's huge. But last year I had a class that was 34. And that's way too much. I mean I only have 32 places for kids to sit. Eight tables and four chairs at each. So that was just too much. I like the small classes, but you need at least twelve kids in class. The person who does the schedule has to take a lot of things into consideration because the kid may want art but the other things the kid needs to take may conflict with when art is offered. I'm sure they would love to level out my classes but it's not possible sometimes."

"You have five classes a day, and a prep."

"Yeah, and I have a homeroom."

"And twenty minutes for lunch."

"Yeah, twenty minutes for lunch."

"Do the other teachers respect the art program or do you feel like you're kind of—well, a lot of times the art teacher feels a little peripheral."

"That's a very good question," said Sheppard. "Sometimes I wonder because the other teachers may not intend it this way but like they'll send down someone to borrow construction paper, Or they'll say, 'I need paint.' And I'm thinking, 'I need it too. And that's why I included it in my budget.'"

"Have you broken them of the habit?"

"Well, I think I have, somewhat. It's OK if it's not habitual. And good things can come of it. For example, the home ec teacher needed some white paint for a project her students were working on. She was new also. And I let her borrow some paint. So later we were working on a papier-mâché project in here, using flour and water and just a little bit of salt, and lo and behold I ran out of flour. Oh man, I was so glad I was nice to the home ec teacher!"

"What goes around comes around, huh?"

"Yeah! What goes around comes around. But some of the teachers will come back and come back. It makes me feel like they don't respect the fact that I have a budget, and this is a department, and it's not just for dipping

Donald Sheppard, Heather Ward, and the winning T-shirt design

into my supplies. But for the most part the teachers are pretty much supportive and some are just really supportive of art. They get excited about it. And that really makes me feel good."

"How about the administration? Are they supportive? You don't get much money."

He laughed and said, "Well I think they're pretty supportive. They're most interested in how the art program is making the school look to the outside. Good public relations. 'I saw us in the paper!' they'll say, and 'Oh, we won the T-shirt contest!' You know, that type of thing."

"The Leon County Parks and Rec T-shirt contest," I said.

"Yeah. You know, at first I thought, 'oh, here's another one,'" he said. "'I maybe won't do this one. We can't do everything.' Then I thought, 'Well it certainly would be nice if one of the kids could see their design printed up.' So we did it in all of the classes. Well, lo and behold, we got a letter back and they chose Sally Maclay's design and she's going to receive a $25 gift certificate. You know, I was so happy. They're going to come here for her team's awards assembly too. She's in the seventh grade. So that was good."

And in the End (Like It Is)

"It seems like you have a really strong commitment to the kids. Is that why you do this?"

"Yes, it's something I was very comfortable deciding on. And art is something I'm very comfortable with. I love the subject. From age five, as long as I can remember, I was always interested in some form of art. I drew pictures on the walls. Sometimes it's scary how immediate teaching art is as far as affecting somebody's life. It's almost overwhelming sometimes. Sometimes it's really unexpected, too. Sometimes you'll get the letter or the card at Christmas or at the end of the year from someone who really is a surprise, you really thought could care less. Those type of rewards are what keep you hanging in there.

"And it's immediate," he continued. "Here's [also] where you can catch the bad habits. You can deal with a child who stole something out of somebody's notebook. You can take them aside and say, 'Where can this take you if you continue this type of action? Let's look at it.' And you can say at this point, 'This is not you. You don't want to be associated with this action.' It's not too late to pull them back at this age. It's not down the road when they're eighteen years old, when they have a record or whatever. It's right here and sometimes it's scary how much you can affect a life. But that's why you're here."

"It sounds like you're pretty satisfied with your work," I said.

"Yeah. Last year I wasn't satisfied with the way things were set up and that's for sure. This year is much better."

"So would you become an art teacher again or would you do something else if you had it to do over?" I asked.

"I think I would," he said. "Well," he said on second thought, "if I was to be real honest, I guess I would like to be somewhere in the Bahamas, painting. But even there I suppose I'd find some kids somewhere. I'd probably call them over and say, 'Hey kids, you want to see this painting? Want to know how to make it?'"

I laughed and said, "Well those are all my questions. Do you have any-thing else you want to say?"

"Hey, did I mention my baby daughter?" he replied. "Do you want to see a picture? She's our little lifeline. She's almost two-and-a-half now and as a matter of fact I have some of her artwork I could show you."

Profile: Donald Sheppard

Current Position: Art teacher at Griffin Middle School, Tallahassee, Florida.

Education: K–12, Quincy, Florida; B.F.A. in industrial design with a minor in advertising from the Columbus College of Art and Design, Columbus, Ohio, 1984; M.S. in art education with certification from Florida State University, Tallahassee, Florida, 1995.

Practicing Artist: "Not practicing as much as I'd like to be," he said laughing. "I'd like to practice a little bit more. I've done some drawing lately. Drawing has been my first love. That used to be my number one thing. I'd love to pick up the pencil and draw in my sketchbook. I got into painting a little bit more in col-lege, so I paint every now and then. I like acrylics. So those are really the two."

Teaching Experience: Three years, all at Griffin Middle School.

Current Teaching Load: Five classes a day and a homeroom period.

Extra Professional Duties and Activities: Yearbook and newspaper adviser, and after-school art club. He also belongs to the local middle school art teachers association and is active in promoting their activities.

Supplies and Expendables Budget: Between $200 and $600 in each of his three years at Griffin.

Salary: "Well, my wife is the accountant, so she knows my salary better than I do. She's an analyst for the state so she keeps track of our family finances. It's somewhere around $23,000, for a ten-month contract. My master's degree gives me just a little bit more than the bachelor's [degree], like maybe $300 more a year or something. It isn't very much. One thing I really like about how we're paid, though, is that you can opt to have your pay spread out for twelve months. That's good, because if you decide you want to lay back in the summer, you can do that. You don't have to cut yards. Just your own. And mine needs to be cut.

"As far as whether I think teachers are paid enough, I came into teach-ing not because of the pay but because of the conviction. But it just so hap-

pened that the pay was just a little bit more than I was making before at *Homes and Land*. So I'm satisfied with the pay. But is it enough for what teachers do? I don't think so. Some people look at a teacher's job as being from 7:15 to 2:30, but they don't take into consideration that teachers take things home, grade things, call parents, and there's a lot, a lot of paper work. And there's a lot of preparation in order to make a class go smoothly. And all that amounts to many, many extra hours. So as far as being paid enough, I don't think so. It's not what they deserve."

8
Study Guide

Setting the Stage: Some Discoveries, in Brief

In these art teachers' stories and through my observations I did find some common concerns and issues. The educational purpose of this book is to stimulate your own search and discussion about meaning in art education, so I don't want to sway you too much toward my conclusions, but I think a few simple observations are obvious and in order. In that context, one thing I found, everywhere, is a blizzard of bureaucratic busywork that teachers feel buries them nose-deep in meaningless mounds of top-down micro-management. I also found that in spite of all those who say kids are different now than they used to be, fundamentally they aren't. There's different stuff going on around them, but at the core they're pretty much the same. In addition, I found one thing that's still exactly the same as it always has been in education: good teachers still care deeply about the life success of their students and say that's the most important reason they teach.

Another thing I found is that most art teachers believe that making art is an act of intelligence and that it should center the curriculum. Although most art teachers incorporate art criticism, aesthetic inquiry, and art history strategies—some well and often—art perception and reception, in general, have a secondary place in the curriculum behind making art. And in that context, creativity is king, with skills development as creativity's primary servant.

Another finding is that these teachers' most common educational goal is helping students achieve positive self-worth through making art. But the means for achieving this end are as varied as the teachers themselves, incorporating many forms of intellectual activity, skills development, and creative expression. In this context, I was very gratified to have my hunch confirmed that there are many good ways to teach art. Finally, I was reinforced in my own belief that the one fundamental, absolutely nonexpendable component of a good art program is a caring, talented, and dedicated teacher. It isn't the curriculum that makes a successful art program, it's the teacher who puts it into practice.

Following are questions to get you thinking about personal, social, and professional issues related to what it means to be an art teacher. It's not important that you agree with every position that a teacher takes. In fact, it

might inspire more thoughtful discussions if you don't. What is important is that you consider the issues as a way to begin developing your own ideas about what it means to be a teacher of art.

The Personal Domain

From the readings, what are the most important reasons these teachers give for teaching art?

Why are they doing it and how do they feel about it?

Did they mostly become art teachers through some driving need or philosophical position or was it for more practical reasons?

What is the relationship between the practical and the personal or philosophical in making these decisions?

Do you think these six art teachers are happy, for the most part, with their lives? (Who is and who isn't?) Why? Would you be happy being an art teacher?

What are these art teachers' greatest rewards, greatest satisfactions, or greatest joys in teaching art?

What do you think will be your greatest rewards in teaching art?

What parts of the job do you think you'll really like?

What are these art teachers' biggest frustrations?

What do you suspect your biggest frustrations will be?

What part of the job do you suspect will get you down?

Do you think you can handle that, long-term?

~~What salary do you think you can expect, starting out?~~
~~Will it be enough for you to live on? To be satisfied?~~
What level of respect do art teachers get? How will you feel about that?

The Social Domain

After reading about and considering the different kinds of social situations described in this book, where and in what kind of environment do you think you want to teach and why?

How is teaching art different or the same at the elementary, middle, and high school levels?

Which do you think you would prefer and why?

What seems to be more foundational/primal/important in the culture of school—the subject-area content (for example, art), or the logistics, disciplinary, and administrative functions? Find instances in the reading to support your argument.

Can you think of any examples from your own life and school to further support your position?

What's it like to deal with students in an art room?

Who are they?

What do they expect?

What should you expect from them? Support your arguments with examples from the book and from your own experiences.

According to these teachers, what kinds of kids should take art?

What kinds of kids do you think should take art?

How much art should students take? Why?

What discipline problems and strategies do the art teachers in this book address?

Which strategies do you think are the most and least effective? Why?

Which of these strategies will you use?

What better ideas do you have? (What will you do differently? How and why?)

What kinds of support do art teachers hope for from their administrators, parents, and the community in general? Do they feel they get it?

What kinds of strategies do they implement to get schoolwide and community support?

Do you think this is necessary or important? Why?

What other strategies can you think of?

How does the culture of each of the schools described here differ from the others in this book?

In your experience, how are schools the same or different across America?

The Professional Domain

What is a normal day like (how many periods/classes are taught, how long is the day, what are the facilities like, what duties are required of an average art teacher)?

What is different and what is the same in different places and at different levels?

What does a normal art curriculum look like at the high school, middle school, and elementary school levels, as described by these art teachers?

Who determines what the art curriculum will be?

Do you have any ideas for structuring an art curriculum?

What budget range can you expect as an art teacher, based on these examples?

What strategies did these teachers discuss to enhance their budgets?

What do you think of these strategies?

Can you think of other/better ideas for enhancing your art budget?

What do these teachers feel are the basic skills that students need to master?

How do they incorporate their instruction in their classes?

Do these teachers think it is important to be a practicing artist in order to be a good art teacher? Why?

What do you think? Why?

What do these teachers in this book think is the most important thing they teach their students?

What do they think or hope students take from their classes that is important?

How do they say they go about facilitating that?

What do you think is the most important thing to be taught in art at school? Why?

How will you go about making sure that happens?

What do these art teachers have to say about the importance in their curriculum of (1) creativity, (2) art skills, (3) art concepts, (4) critical thinking, and (5) art appreciation?

What would you say the relationship of these five things is?

How would you rate them—from the most to the least important?

Is there anything they left out that you think is important?

What strategies do these art teachers discuss for evaluation or grading student work?

Which of these do you think are good? Not good? Why?

Do you have any ideas for evaluating or grading student work?

How do these art teachers' expectations affect the level and kind of student accomplishment?

What strategies do you notice these teachers putting in place to reinforce their expectations for accomplishment in art? Find examples in the reading that support your arguments.

How are teaching strategies different at the three different age levels? Give examples from the reading.

How important is classroom discipline in art accomplishment?

What strategies do these teachers put in place to promote excellence—not just accepting enough as enough?

What other strategies can you think of or have you encountered in your art classes?

What do these teachers have to say about whether art should be separate/independent/for its own sake or whether it should be integrated with other subjects at school?

What do you think?

Which position will make art more valuable in the culture of school? Why?

Appendix
Interview Guide

Where were you born and when and where did you grow up?

Tell me about your education including elementary, secondary, and postsecondary education.

(If you haven't done so already) please describe your teacher training. How effective was it?

(If you haven't done so already) please describe your work history, including other jobs you've done, how many years you've been a teacher, and where.

What kind of certificate do you have?

What inservice training is required for you to keep your certification?

What's your salary, where do you fit in your district's salary scale, and how do you feel about your salary?

Why did you become an art teacher?

Is there a favorite teacher that you remember? Did s/he have any influence on your career?

Are you satisfied with what you do? Have you ever thought about doing something else?

What's the most rewarding/satisfying thing about being an art teacher?

What's the most frustrating thing?

Describe your school (location, size, population, special conditions, community).

Describe your art program (goals, courses taught, scope and sequence, facilities, supplies, other teachers and what they teach, number of students, how many hours a week they have art, class size, teaching load, number of periods, length of your day, homework).

Describe a typical day in as much detail as possible.

What extra duties and other non-art-related tasks are you assigned at school?

What extra art-related/professional duties do you have (art club, professional organizations, etc.)?

Do you have social or professional contact with other art teachers on a regular basis? Is there some formal mechanism for this in your district? Describe. What do you discuss?

What would be your ideal situation (class size, teaching load, facilities, focus, budget, salary . . .)?

Who decides what you teach (National or State Standards, district curriculum, individual choice relationships)?

What's the most important thing you teach?

What are your long-term goals for your students? (What do you want them to take with them from their art education?)

What skills and/or concepts are most important to be taught in art?

What's the role for creativity in your program? How does it relate to skills and concepts?

Are you a practicing artist? Describe, if so. How important is that for an art teacher?

How do you motivate your students?

What do you think about (1) competitions/displays, (2) homework, (3) copy work and/or researching the work of other artists, (4) breadth versus depth approaches to instruction?

What's the role of criticism, art history, and/or aesthetics in your program?

What's your position on grading (what, how, and why)?

What's more important, student attainment or student satisfaction?

Is there any student who really stands out in your mind for any reason?
Is there anything else about your philosophy of instruction that you want to tell?

How important is art in society/in life?
How important do you think art is in general education? Why?
Do kids get enough art in school?
What kinds of kids should take art and what kinds of art should they take?
How important and how well supported is art in your school (administrative support, non-art teacher support, community and parent input/support)?

What would you change, if you could, to make your job better?
Would you become an art teacher again, given the opportunity to start over?
Is there anything else you'd like to say?

References

Anderson, R. 2000. *American Muse: Anthropological Excursions into Art and Excellence.* Upper Saddle River, NJ: Prentice-Hall.

Anderson, T. 1995. "Toward a Cross-Cultural Approach to Art Criticism." *Studies in Art Education* 36 (4): 198–209.

Dewey, J. 1934. *Art as Experience.* New York: Capricorn.

Eisner, E. 1991. *The Enlightened Eye: Qualitative Inquiry and the Enhancement of Educational Practice.* New York: Macmillan.

Emerson, R., R. Fretz, and L. Shaw. 1995. *Writing Ethnographic Field Notes.* Chicago: University of Chicago.

Gablik, S. 1997. *Conversations Before the End of Time.* New York: Thames and Hudson.

Geertz, C. 1973. *The Interpretation of Cultures.* New York: HarperCollins.

MacDougall, D. 1995. "The Subjective Voice in Ethnographic Film." In *Fields of Vision: Essays in Film Studies, Visual Anthropology, and Photography,* edited by L. Devereaux and R. Hillman. Berkeley, CA: University of California.

Marcus, G., and M. Fischer. 1986. *Anthropology as Cultural Critique.* Chicago: University of Chicago.

Postman, N. 1995. *The End of Education: Redefining the Value of School.* New York: Knopf.

Seidman, I. 1998. *Interviewing as Qualitative Research.* New York: Teachers College Press.